The Company of Others

THE COMPANY OF OTHERS
Copyright © 2005 by PLAN Institute for Caring Citizenship, Sandra Shields and David Campion

ARSENAL PULP PRESS
341 Water Street, Suite 200
Vancouver, BC
Canada V6B 1B8
arsenalpulp.com

PLAN Institute for Caring Citizenship
#360 – 3665 Kingsway
Vancouver, BC
V5R 5W2
inquiries@planinstitute.ca, www.planinstitute.ca

Arsenal Pulp Press gratefully acknowledges the support of the Canada Council for the Arts and the
British Columbia Arts Council for its publishing program, and the Government of Canada through
the Book Publishing Industry Development Program for its publishing activities. PLAN Institute for
Caring Citizenship thanks Social Development Canada, Office of Disability Issues, for their support
of this publication.

Text and cover design by Susan Turner at Digitopolis Media Corporation
Printed in Canada by Teldon Print Media with paper supplied by Cascades Resources

THE COMPANY OF OTHERS
STORIES OF BELONGING

Sandra Shields & David Campion

with an introduction by John Ralston Saul

Arsenal Pulp Press / PLAN Institute
Vancouver

Library and Archives Canada Cataloguing in Publication

Shields, Sandra, 1965-
The company of others: stories of belonging / Sandra Shields,
author; David Campion, photographer.

ISBN 1-55152-186-5

1. Mentally ill—Canada—Family relationships. 2. Mentally ill—Care—Canada. 3. People with mental
disabilities—Canada—Family relationships. 4. People with mental disabilities—Care—Canada.
5. Older people—Canada—Family relationships. 6. Older people—Care—Canada. I. Campion,
David, 1965- II. Title.

RC455.4.F3S47 2005 362.2'042 C2005-904974-X

ISBN-13 978-155152-186-2

CONTENTS

Preface

THE YEARNING TO BELONG IS UNIVERSAL. Who among us has not experienced the ache of looking into a world we long to be part of? Our connectedness to one another is often what's best about being human. It is the foundation of our identity. We know our lives have meaning when we are in the presence of others who care about us. When we are cut off from others, we are set adrift, cast away from our true nature.

Many people in our society live without caring ties to buoy them on their journey. Their deep isolation and loneliness call to us to extend hospitality and the embrace of belonging. Their yearning is our invitation to be our most human. When we are curious, warm, and welcoming, we are all better off for it. Each time a person moves from isolation to connection our neighbourhoods become safer, our communities more vibrant, and our society more cohesive. The ties and bonds are reciprocal.

For almost twenty years, PLAN has focused on ways to welcome people into the heart of community. We have a deep conviction about the power and potential of relationships

to transform lives and communities. We have grown to understand that everyone, even the most vulnerable members of our society, becomes a contributing citizen when we are engaged in the give and take of caring relationships.

David Campion and Sandra Shields have created an ode to the beauty of caring bonds. They capture what happens when "outsiders" (people our society knows very little about) become "insiders." Belonging and meaning circle back and forth, round and round, through each of their stories. Their work is an elegant and intimate call to possibility, an invitation to imagine what the world has to offer each of us when we reach out.

Al Etmanski and Vickie Cammack
Co-Founders, PLAN (Planned Lifetime Advocacy Network)
www.planinstitute.ca
www.plan.ca

Foreword

THERE IS NO IDEA OF SOCIETY MORE ANCIENT than a circle of friends. And there is nothing more predictable than the discovery by such a circle, who have come together to support one among them, that the one in need is somehow helping the others.

Why does almost every philosopher since the beginning of recorded time come back to this idea of mutual support, of the emotional sustenance needed and found in organized friendship? The answer simply is that life has several essential components. And one of these — one which can be seen as a metaphor for civilization — is that we live through the mirror of the other.

We can see this in the literature of our past. Gilgamesh, hero of the very first Western dramatic story — the perfect leader, handsome, rich, surrounded by admirers — discovers that he cannot live without his friend Enkidu; he discovers his own mortality through his friend's death. More to the point, he discovers his own mortality because he has discovered a sense to his life through friendship. This same discovery is repeated throughout Homer, the Greek legends and plays, the Anglo-Saxon myths, and so on through story after story.

What did Socrates mean: "The unexamined life is not worth living?" One interpretation is that we become conscious of both the potential and the limitations of our existence through the mirror of those around us. And that was what Adam Smith

meant when he focused all of his philosophy on our need to *imagine the other*. We are not *the other*; we cannot be the other. Our destiny is to be ourselves. The readers of this book will not become Margaret, Betty, Jeff, Rick, or Erin. But the people who have joined the circles around these five individuals have in a sense examined themselves. And you, the reader, will perhaps get a hint of how you might better *imagine the other* and examine yourselves.

What of Margaret, Betty, Jeff, Rick, and Erin? Well, they'd be the first to know what their disabilities are. They also want friends. And they also want to be part of a community, just the way we all do. Forty or fifty years ago, their disabilities probably would have led them to being treated by society in an unacceptable way. In fact, many with disabilities still are marginalized in unacceptable ways.

Think of the well-intentioned but foolish decision thirty odd years ago to shut down old-style hospital facilities for Canadians with mental illnesses under the naïve delusion that their needs could be handled with drugs. How those drugs would be administered in the real world was never addressed. To address that need, you would have had to *imagine the other*, which would have led to the organization of circles of friends, assisted and group housing, and so on. Instead, we got a falsely rational, administrative solution, resulting in the sad fact that today over half the homeless on Canadian streets suffer from mental illnesses.

The five people around whom this book is written convey a message about the essential role that friendship plays in their lives, each of them, as well as in the lives of the individuals who make up each of their circles. What makes these five people so special? The answer is disarmingly simple.

If you have a disability, you have to try harder to make your life work; to make a place for yourself, to get through the practical challenges that you face on a daily basis. You have to examine yourself as best you can, and make a constant effort as best you can. In other words, you have to be far more conscious than we "able" people who float along in life, lost in the illusion that we are OK and therefore in control of our lives and therefore with little to examine.

Margaret, Betty, Jeff, Rick, and Erin are the centre of their circles, but not simply because they are the reason for their circles' existence. They are at the centre because they bring their example of consciousness and effort to the lives of their friends. I have said it before, but it bears repeating: our society has come to confuse speed with intelligence. We are wrong. There are many kinds of intelligence. And the most interesting kinds of intelligence turn around consciousness, consideration and care.

PLAN is an organization centred on this understanding of multiple intelligences and of citizenship as a much richer and more complex engagement than we often

imagine. Above all, it is an organization centred on the reality of building friendships to support people with disabilities. Everyone involved in PLAN has quickly discovered that this business of building friendships is a two-way street on which everyone must be a beneficiary.

I began by pointing out how circles of friends have always been at the heart of our idea of society. If the convenor, so to speak, is someone with a disability, this idea of shared multiple friendships becomes all that more clear. It also becomes more clear as a model for society. Why? Because the price of each person's entry into the circle is their — your — willingness to *imagine the other*, and thus become more conscious of themselves.

This book is about the core idea of any society. It is also a reminder of how careful we must be when we expand our notion of society to hundreds, thousands, even millions of people. People massed in great numbers have a false sense of certainty; sometimes frighteningly so. It is important to protect ourselves from ourselves by being able to hear the voice of someone like Margaret, with her sense of this unconscious reliance on reassurance, who asks her friends whenever she feels it is necessary: "You okay? ...You sure?"

John Ralston Saul
July 2005

Five Circles

ONE IN SIX NORTH AMERICANS WILL HAVE A DISABILITY at some time in their lives, and although modern society has become more inclusive, people with disabilities often find themselves isolated and unable to sustain a network of family and friends that they can rely on. Over the past thirty years, "circles of friends" or "social networks" have been developed around people who are vulnerable as a result of disability, age or mental health.

The models vary, but whether they are called circles or networks, the idea is to prevent loneliness by being more intentional about friendship. Someone usually organizes or facilitates the group and sometimes that person gets paid. The other network members are volunteers, often neighbours, fellow churchgoers, people from the community. Some groups meet every month; others get together once a year. Potluck suppers are common and so are birthday parties.

The Planned Lifetime Advocacy Network (PLAN) is a charitable organization dedicated to supporting such networks and circles of friends across Canada. Its headquarters are in Vancouver. Near the end of 2003, the PLAN Institute commissioned me and my husband, photographer David Campion, to make a book about the impact of intentional networks on the people who participate in them. Photo-documentary work tends to centre on social problems, so it was a departure for us to consider solutions

instead. Al Etmanski and Vickie Cammack with the PLAN Institute asked us to document a cross-section of networks. We worked with researcher Nancy Rother, who conducted a national survey on the subject, to identify a handful of networks across Canada that we could focus on. We wanted networks that had endured and that were succeeding in reducing isolation. We chose to cover three networks around people with intellectual disabilities, one network that supports an aging grandmother, and another that supports three men with mental health concerns.

A few years earlier, we had joined a support network ourselves. We knew that networks can enrich lives, and we also knew that they are not easy to create. In compiling this book, we wanted to share people's stories of hope but did not want to understate the challenges involved. We spent between ten and thirty days with each network, getting to know the person at the centre and also spending time with his or her friends and family. Documentary photography often looks at the exotic, but for this book David photographed simple acts of friendship: people going for coffee or sharing a meal or just sitting and talking. We spoke with the people involved in each network both in formal recorded interviews and in casual conversation. We spent whole days with our subjects. By the end of our time with the five people whose stories appear here, we had seen clearly that each of them benefited from having a network. Indeed, almost everyone involved said their lives were richer for the experience.

We began *The Company of Others* in Vancouver in January 2004, when we met a young woman named Erin Tesan. Erin has an intellectual disability and is at the centre of a circle of girlfriends. Erin's mom and a few of her friends were shy about being photographed, but Erin didn't mind being in the eye of the camera. We followed her through her daily routine and joined her and her friends on coffee dates and trips to the mall.

In March, we travelled east through the mountains to Nelson, British Columbia, to meet Jeff Moorcroft, his mother Megan and the dozen citizens of Nelson who make up his network. Jeff is a private man who lives in his own place and has a bit of an intellectual disability. In the first few days of our visit, he often asked David to stop taking photographs. The two men spent several long afternoons by the tracks watching trains and getting to know one another. By the end of our two weeks in Nelson, Jeff was saying to David, "Hey, you better take another photo."

The apple blossoms were coming out when we arrived in the southern Okanagan Valley of B.C., where a First Nations family has created a network to support their aging mother, Betty Terbasket, in her home of seventy years. Every afternoon for ten days we walked down the road to Betty's house to observe the "grandma schedule" in action, and Betty accepted our presence in her kitchen as if it were the most natural thing in the world.

We spent most of April in Lethbridge, Alberta, with Margaret Enns. Margaret has Down syndrome and she is at the heart of a large network of friends from the Mennonite church she has attended all her life. Margaret took delight in showing us her home, introducing her friends and taking us along whenever she went out with them. Before we left, she asked for a photograph of us and added it to the many others in her purse.

Our last stop was Montreal, where we spent two weeks with Rick Ottoni and his roommates George and David, all of whom live with schizophrenia. We visited the three men daily, and they accepted our presence in their small apartment with grace and good humour. We were there when volunteers in the network that helps support the men stopped by to visit or go grocery shopping or help with the cleaning. We shared memorable meals and spent hours talking philosophy with them around the kitchen table.

On a beautiful June day we drove out of Montreal and headed for home on the west coast, with hundreds of rolls of film, hours of taped interviews, and pages of notes. We had seen how ordinary people are changing the world one circle at a time and we were excited about sharing the news. Then we began the year-long process of going over contact sheets, shifting through notes and creating the five stories that follow.

Sandra Shields and David Campion

Jeff

JEFF MOORCROFT IS FIFTY-FOUR YEARS OLD and lives in Nelson, British Columbia, in a condominium that he bought with some help from his parents. When his dad died a few years ago, his mother Megan sold their place in the country and moved into the condo next door to Jeff's. Most days, Jeff makes soup and sandwiches and invites his mother over for lunch. When he goes to fetch her, he calls out, "Mom, you still there? You still alive?"

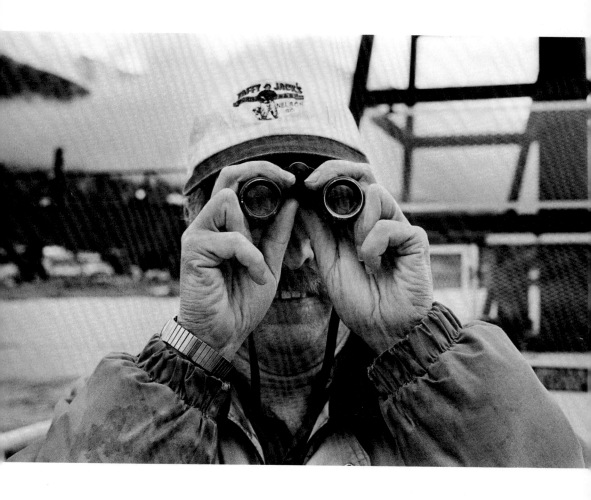

"Well, I am eighty-four," Megan says when she tells the story, and she laughs. She and her husband were in their seventies when she set about organizing a support network for Jeff. She was worried that he would have trouble getting by when she and her husband were gone. Jeff had lived on his own for years, but with his intellectual disability he had to rely on his parents for help with personal decisions and matters like bank accounts, taxes, and medical care.

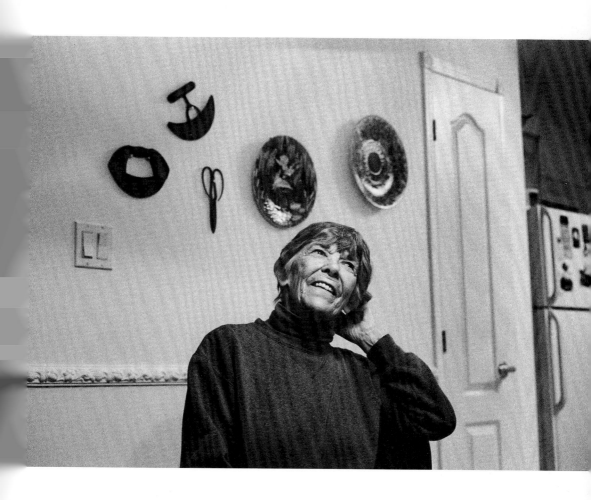

Many people in Nelson knew Jeff as the guy who stood for hours by the railway tracks watching the trains. His passion for trains springs from his childhood. The family had a mink farm in the bush country of northern Ontario, where the only way in and out was by rail. It was there, when Jeff was two or three, that Megan realized he was learning to talk more slowly than other kids his age. When she had him assessed by a specialist, she was told that Jeff would never learn anything, a diagnosis that she was unwilling to accept. "I was so mad," she says, recalling that time and how little doctors knew about developmental disabilities.

A few years later, the family sold the mink farm and moved to the fishing village of Gibsons on the Sunshine Coast north of Vancouver, where Jeff's dad worked in a pulp mill. In the 1950s, students with disabilities went to segregated schools and the closest one was in Vancouver, a two-hour ferry and bus ride away. Megan got together with a couple of other parents in the area and they started a school in Gibsons for kids with disabilities. At first they met in a church hall, then they moved to the Women's Institute. Jeff was one of the students, and for a few years Megan was the volunteer teacher.

When Jeff was nine, he started going to school in Vancouver. Megan went with him the first day, but after that he made the trip by himself, riding the ferry down the coast, then catching a bus and transferring to another bus before arriving at the school in North Vancouver. Workers on the ferry kept an eye on him and the cook gave him treats. He got to know the ferry captains and bus drivers, and soon he was almost as passionate about ferries and buses as he was about trains.

When Jeff's dad retired from the pulp mill, the family left the coast and moved to a farm in the mountains of the Slocan Valley. The small city of Nelson was nearby, and when Jeff turned thirty, Megan suggested he try living on his own in town for a while. After a week, Jeff said he already felt like his own boss, and though he often visited his parents on the farm, he never moved back.

Jeff worked odd jobs in Nelson and received a small disability payment from the government each month. In the summer he rode his bike around, visited the beach, and was a regular at the coffee shops downtown. Winter or summer, Jeff could often be found standing at the bend where the main road overlooks the rail yards and the shops where the diesel engines were repaired. Railway employees arriving for the six a.m. shift passed Jeff on their way down to the yards, and he would tell them what trains were due and when. He knew the numbers of the different engines, and some of the engineers joked that he knew the trains better than they did. He liked the cabooses best.

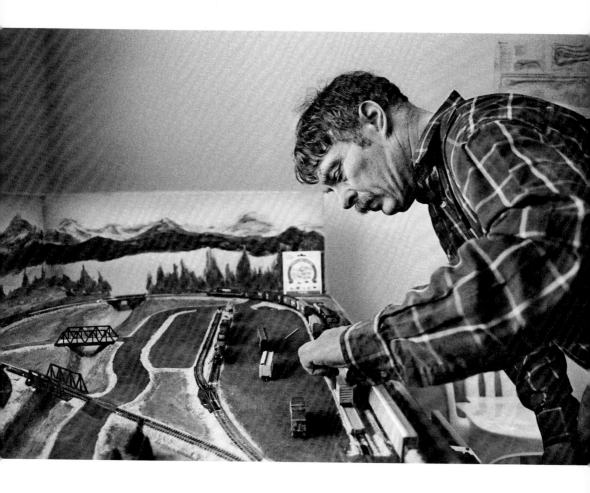

Megan had heard about support networks at a workshop in Vancouver put on by PLAN, an organization begun by a group of aging parents who also had adult children with disabilities. Megan's husband was skeptical at first (he liked to say that they had always paddled their own canoe), and Jeff was reluctant as well. Megan cajoled Jeff into going for coffee with Deb Kozak, a long-time advocate for people with disabilities. Once Deb and Jeff got to know each other, they worked with Megan to make a list of people who might participate in a support network. Deb called them all up and invited them to come over and talk about forming a network for Jeff.

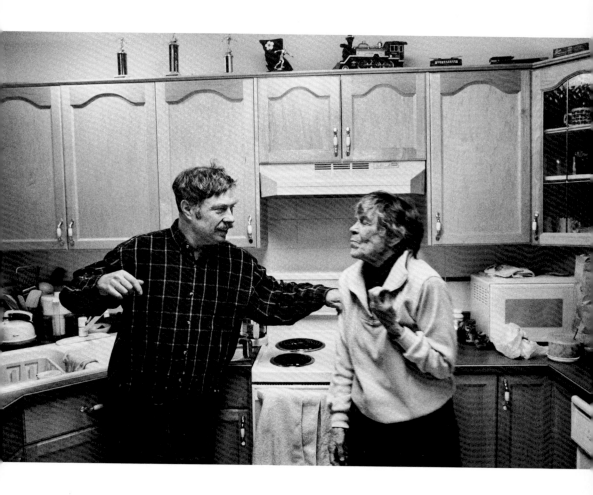

The first meetings were awkward. No one knew anyone else and Jeff was quiet. When local politics came up, everyone disagreed. Deb's enthusiasm helped carry them through, and as Jeff's dad warmed to the idea, so did the others. Jeff settled into the role of host by serving coffee and tea, and even making small talk. That was almost a decade ago.

The composition of the group changes as people move away or have to deal with changing circumstances in their own lives. Everyone still feels the absence of Jeff's father, who died six years ago. Now the group has a good understanding of Jeff's health and how he manages his finances. When Megan is gone (when she "goes into orbit," is how she likes to put it), the network will be able to help Jeff keep his life in order.

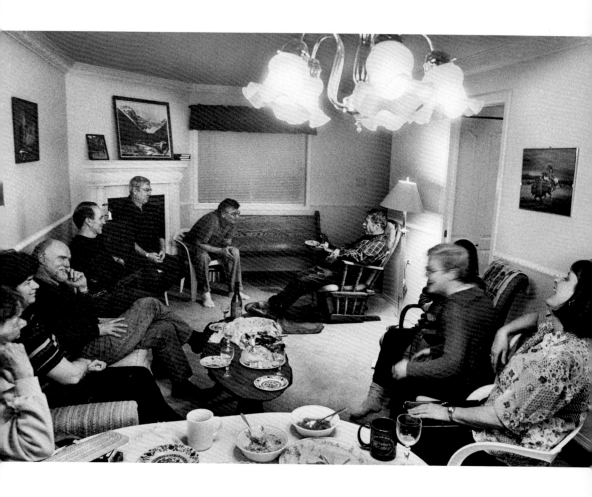

These days, Jeff's network feels like an extended family, especially when they gather for their monthly potluck. Jeff cleans his kitchen and bathroom and mops the floor (or "dungs out his place," as his mom says). The group tends to be civic minded: one member served on the school board, another ran for city council, three have been given Citizen of the Year awards. In Jeff's living room they bring out their diverging opinions and still leave on good terms. When the conversation grows heated, Jeff pours coffee and watches with a smile.

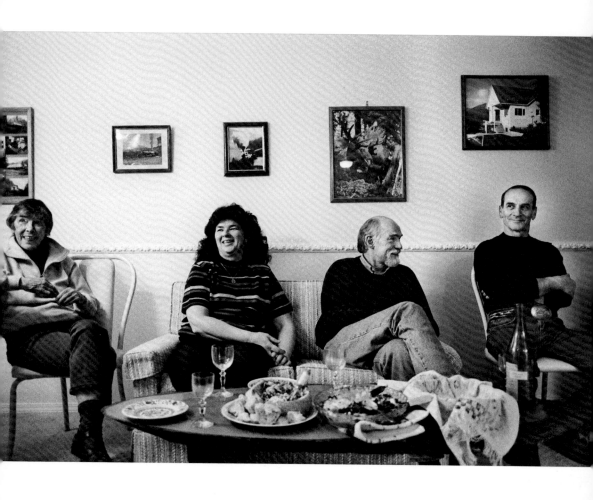

Many years ago, while Jeff was watching the train tracks in the early morning, an engineer named Tommy Morello asked him if he would like to ride in the engine on a short run to a nearby town and back. After that, Jeff often hitched rides in the train with Tommy.

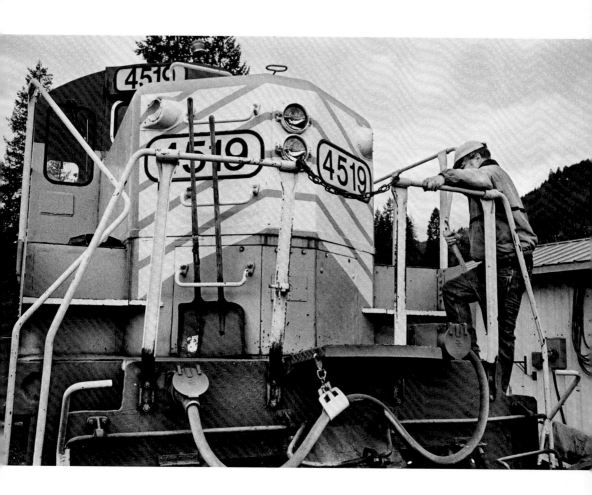

Now Tommy and his brakeman Jerry Svida and their wives are all part of Jeff's network. Tommy and Jerry work for a private railway these days, running wood through the mountains to the American border. Jeff rides along sometimes. By now he's an old hand at trains, but he still splits a grin when he gets to blow the whistle.

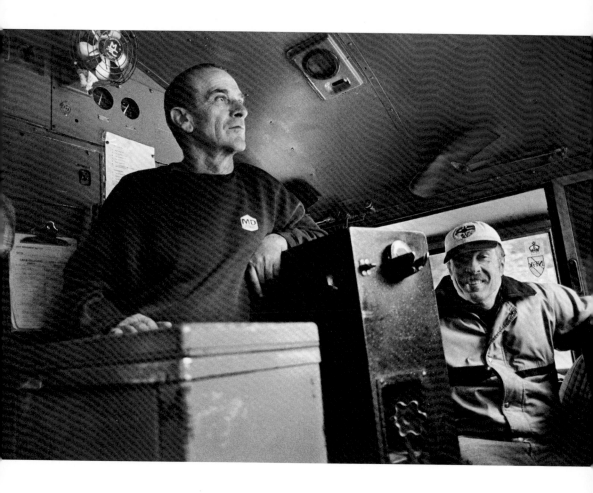

The Nelson rail yards aren't as busy as they used to be since the regional headquarters moved to Cranbrook. By 1998 the railway had phased out all the cabooses, too. Jeff still says they should bring the cabooses back. These days he spends afternoons at the bus station, where he once had a job sweeping up in the summer and shovelling snow in the winter. Though he's no longer on the payroll, he still likes to help out. He meets the bus, and when the loading area gets congested, he helps direct the passengers.

Jeff knows most of the drivers and chats with them before he climbs aboard to collect the bottles that passengers leave behind. Sometimes, on a cold night, one of the drivers will give him a ride and the bus will make an unscheduled stop.

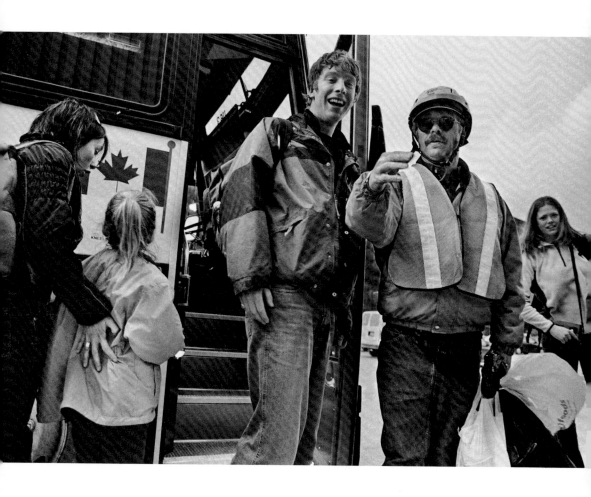

Jeff donates the bottles he collects to the Special Olympics bowling league that he has belonged to for years. The owners of the bowling alley, Jim Dow and his wife Nancy, are the volunteer coaches. Practices are on Saturday afternoons and Jeff goes every week for two hours of fun and some serious bowling.

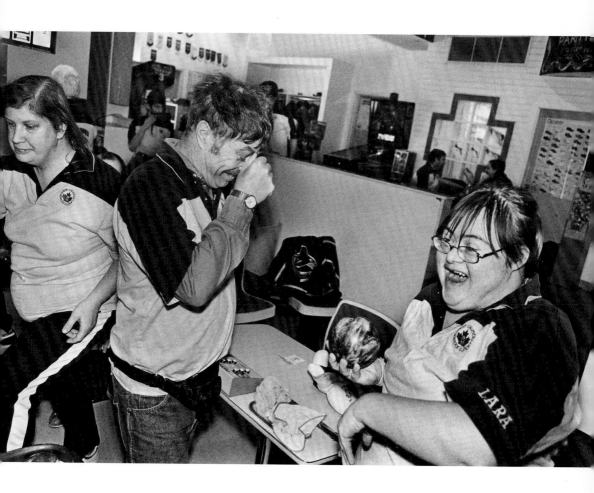

Jim and Nancy are both in Jeff's network. In the months after Jeff's father died, Jim started getting together with Jeff for hamburgers on Friday nights. They eat at the A&W in the food court in the mall where the bus station is, and afterwards Jim picks up the bottles Jeff has collected that week for Special Olympics.

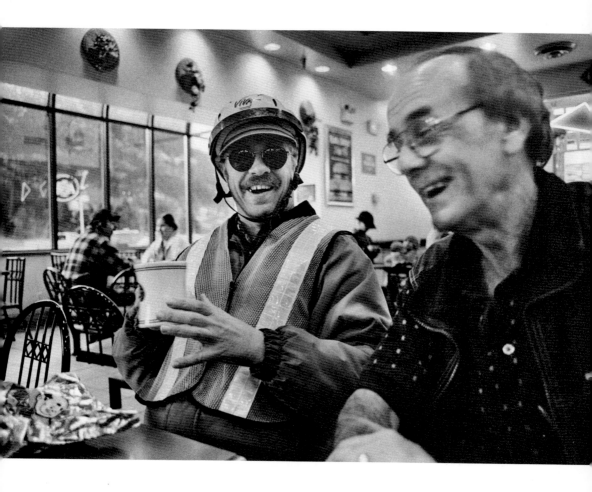

In the summer, when Jeff is out riding his bike, he takes a plastic bag and picks up bottles and cans from the side of the road. On the way to the beach, he rides past the home of his friend Jerry, the brakeman on the train, and whenever he catches Jerry outside, Jeff always asks: "You going to bring those cabooses back?"

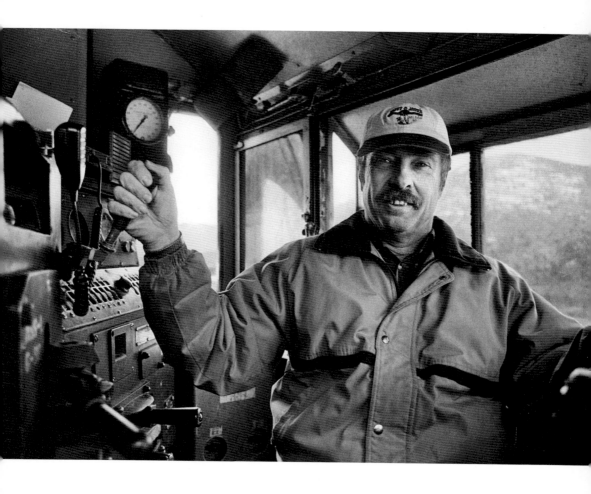

Betty

BETTY TERBASKET HAS LIVED IN THE EMBRACE of the hills of Blind Creek Ranch since she came here as a young bride seventy years ago. She was born just up the road, and around these parts of the southern Okanagan, people call her Grandma or Auntie Betty, even if they're not related.

Betty lost her first child to pneumonia during a winter when the valley was snowed in, then she and her husband raised eight children on Blind Creek Ranch. After her husband passed away, she watched their grandchildren grow up and start families of their own. Many of them live nearby. Her sons come for coffee in the morning. Her great-grandchildren arrive after school and, like their parents before them, eat sandwiches at the kitchen table.

The family say Betty is the one who brings them together.

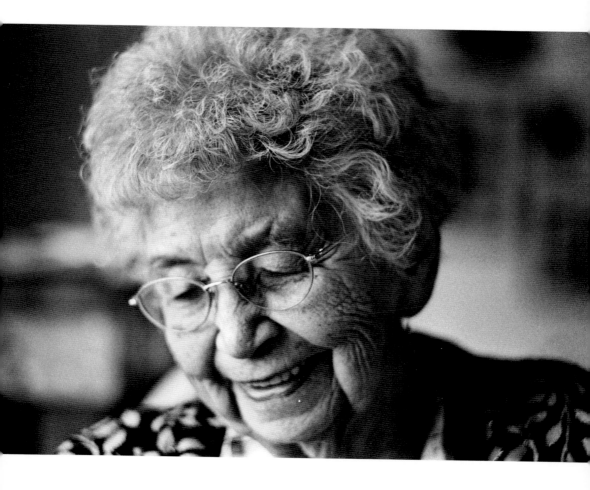

Betty had hip surgery a few years ago and came home in a wheelchair. When her memory began to give her trouble, the doctor took her middle daughter Millie aside and suggested that Betty be put into extended care because it was no longer safe for her to live on her own. "She won't survive," Millie said, and the rest of the family agreed. Now Millie says, "We just knew that if she had to go in a home, she wouldn't be with us today."

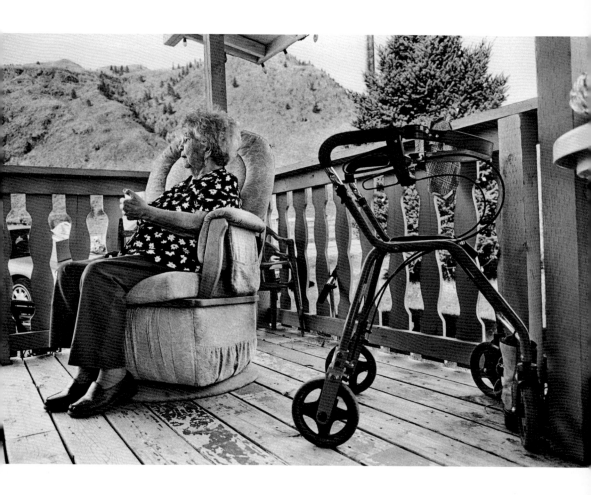

From her kitchen window, Betty can see the daycare where Millie works with the children of the community. "She depends on me because I'm the one living here," Millie says. She's the only one of Betty's three daughters living on the ranch; her house is on the other side of the hayfield, a few minutes away.

A home-care worker began spending the day with Betty. Millie visited at lunch, came back in the evening, and often spent weekends with her mom, too. Weeks became months and Millie became exhausted. One day she found herself getting angry with her mom and realized she couldn't do this on her own.

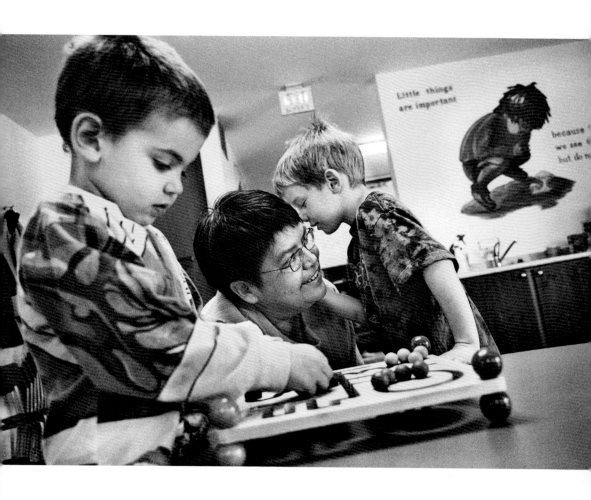

Little things
are important

because
we see
but do n

Until Millie asked for help, the rest of the family hadn't realized that Betty needed someone with her around the clock. Her daughters and granddaughters got together and started what they call the grandma schedule. For several years now, a dozen family members have made Betty part of their routine, spending time with her on evenings and weekends, watching that she doesn't forget things on the stove, making sure she takes her pills.

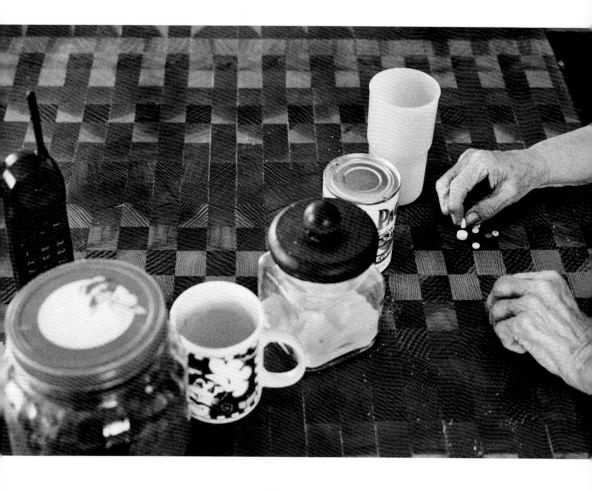

Betty has not found it easy to accept care from her granddaughters, all of whom remember her tenderness when they were children. After a life of looking after others from morning to night, she hates to feel like a burden, and there are days when she's grumpy and days when she's blue.

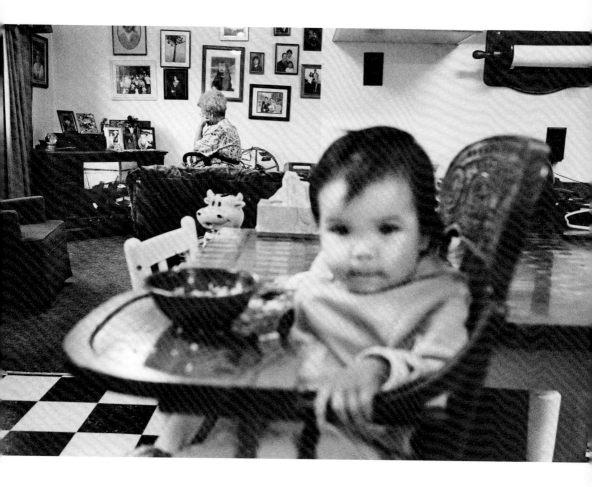

Until a few years ago, Betty always drove everywhere. She would pack up whichever grandkids were around and they'd go to town, to a ball game, to visit family. Going for a drive is still one of her favourite things, even as a passenger, and it's become one of the regular grandma schedule activities. Houses and landmarks trigger her memories. "Everywhere we go, we get stories," one granddaughter says. "They are like treasures." "She gets disoriented when she's somewhere else," says another granddaughter, "so being here on the land and being in the house, being here so the uncles can drop by and she can feed them, having us here, it really matters."

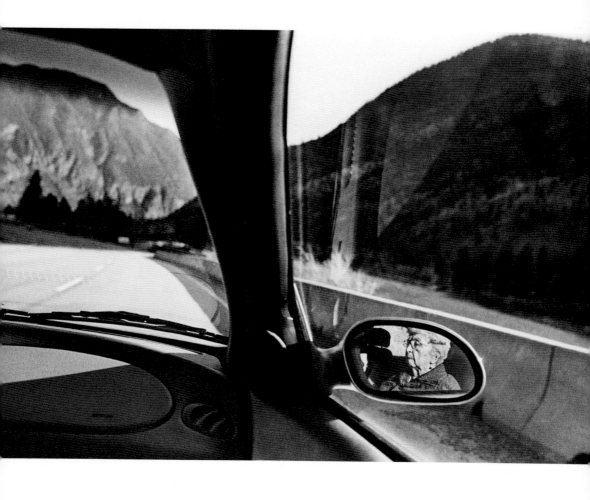

One day, driving to the grocery store, Betty points to a thin track along a steep rise. Years ago, when her husband was ranching, she used to drive the big farm truck up these narrow roads into the mountains to take a hot lunch to the men. Later, cruising the grocery aisles, she pays close attention to the shopping. It's important to Betty to have meat and bread in the house. She is used to cooking for twelve people. "She needs her space," her granddaughter says. "She needs her home and her family. That's what keeps her going: the fact that she has someone to cook for, to put the coffee on for her sons who stop in every morning, to cook lunch."

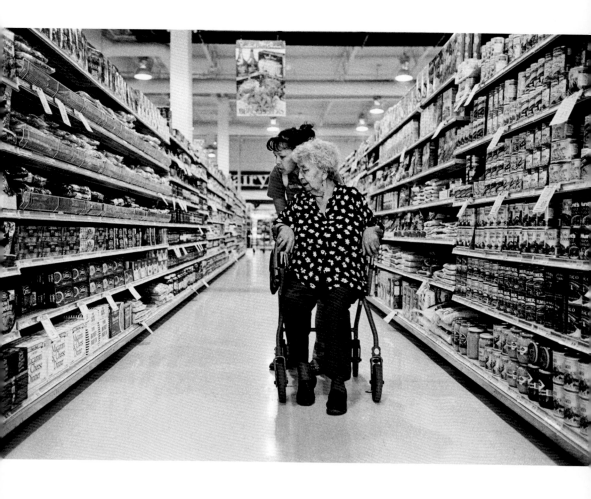

Everyone on the grandma schedule is busy. Two of Betty's daughters and several granddaughters live more than an hour away in Kelowna, and each of them comes down one weekend a month to take a turn on the schedule. "We've had fights because we're all extending ourselves to our limits," one granddaughter says, which makes Millie laugh. "We're all bossy." The granddaughter says it's been hard to make the schedule work. Getting together for meetings is almost impossible, so conflicts can turn into arguments before they are dealt with. "We've had to iron it out with a lot of tears."

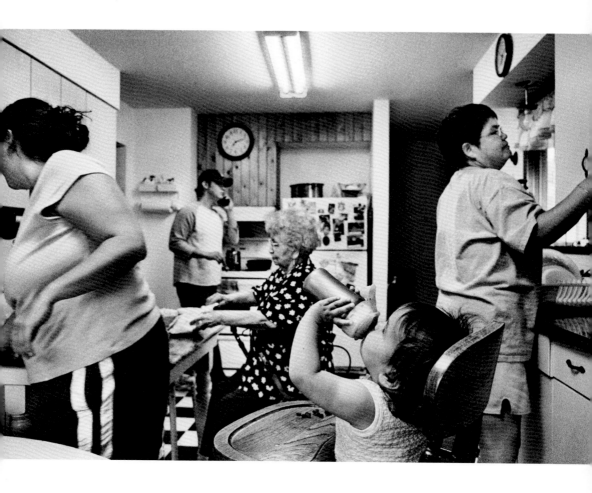

In Betty's day, women took care of the house and family, and men worked outside and came in to be fed. Two generations later, her grandsons live in a different world: two of them are on the grandma schedule and a third does backup. Each of them is comfortable taking care of the woman who once took care of them. "The respect doesn't change," her grandson says.

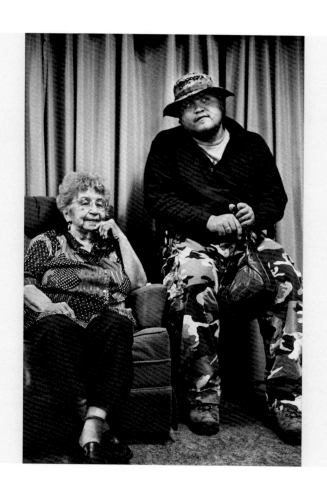

Betty's first language is Okanagan. Her own children don't speak it, but her great-grandchildren are learning the language in elementary school. They call Betty their tupa, great-grandmother. "The biggest benefit for me," says one granddaughter, herself a mother, "is that the girls are spending time with their tupa. To have a great-grandmother and get to spend time with her — how many people have that?" In the spring, when the youngsters climb into the hills, they can see their tupa's house there in the valley, just before the bend in the road.

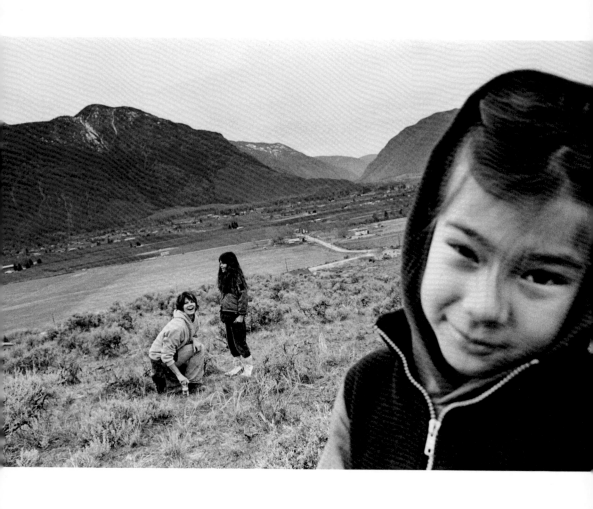

Betty's youngest great-granddaughter Morgan visits every day, enjoying the same tender attention, the humming and holding that nurtured her mother Lisa thirty years earlier. One evening, Morgan pulls magnets off the fridge while her tupa and her mother cut fabric for a quilt. Betty has always quilted, and Lisa learned it from her. They're making a quilt for each of the caregivers on the grandma schedule; last year they made nine quilts, and they still have more to do.

Lisa is on the band council, where she grapples with balancing traditional and contemporary modes of governance. It was with Betty's encouragement that Lisa ran for band council last fall. "She's one of the main reasons I finished school and went on and got my master's," Lisa says. "Having a strong grandparent gives you that push, that soft push, that nurturing when you need it."

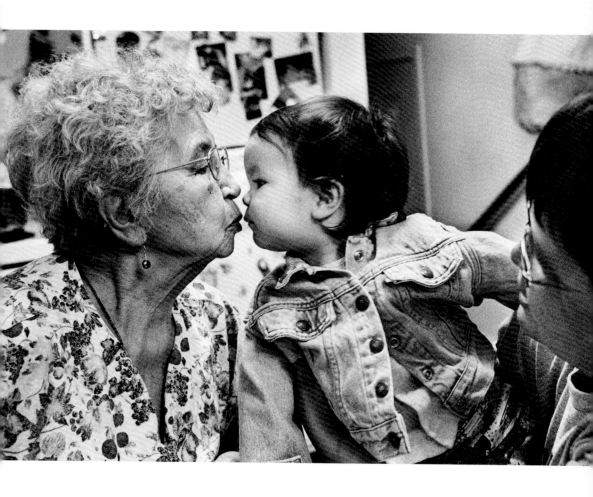

Betty's sons took over the ranch when their father died. The house that Betty lives in now sits against the hills at the end of the hayfield. The original ranch house is down by the river, across from where a big barn once stood, which is now commemorated in paintings and photographs.

For the first twenty years of her married life, Betty lived in the house by the river, raised her kids, and cared for her husband's grandparents, both of whom lived for more than a hundred years. Shortly after they died, a bedridden uncle moved in. "I just wonder how she did it," her daughter Eliza says. "In those days we didn't have plumbing, running water, or anything." Still Betty kept her babies in clean diapers, tended to the old people, and made everyone three square meals a day.

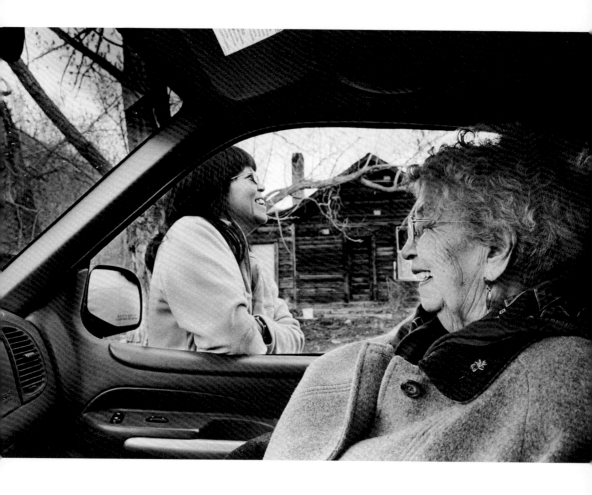

The leaves are coming out on the cottonwoods along the river when the men of the family gather to brand calves at the corral by the old ranch house. Betty stays in the car. Lisa passes Morgan in, onto her tupa's knee. "She was getting scared of those cows," Lisa says. They eat Cheezies and Betty talks about her life in the old house with washboards and coal-oil lamps. "And then we got a hand pump in the kitchen," she says, "so we didn't have to haul water from the river."

In the corral, a calf squeals and its mother bellows. "The babies are crying," Betty says to Morgan. "*Mmaaa*. They want their mommies." "*Mmaaa*," Morgan says.

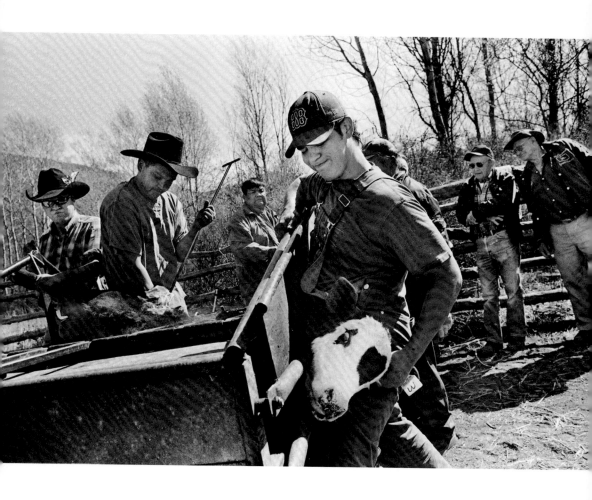

Back at the house by the hayfield, Betty's youngest daughter Pauline says that Morgan and her tupa are kindred spirits. She looks out at the hills beyond the window. "The place, for her, is what gives her meaning. My mother has no desire to travel or go far away. Her family is just up the road. She has a place because she wants her grandchildren to have a place. It's like she had a responsibility to ensure that Morgan has a sense of place, a sense of us, a foundation, a home. My mother has handed down a sense of belonging to three generations."

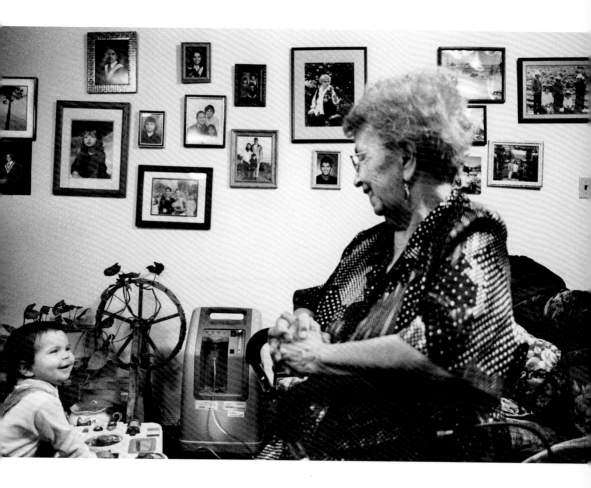

Margaret

MARGARET ENNS HAS BEEN GOING TO THE SAME CHURCH in the town of Coaldale, just outside of Lethbridge, Alberta, since she was born forty-one years ago. For fifteen years now, Margaret has enjoyed the support of a network of church members, several dozen strong, who have made a commitment to be part of her life.

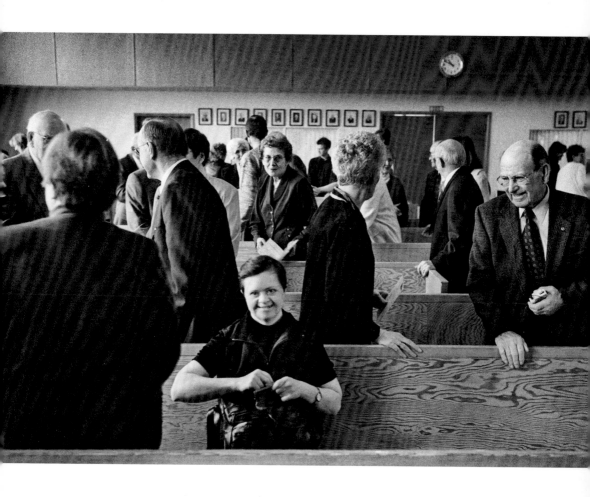

Margaret is famous among the congregation for the hugs she bestows on people. Her friends say that she loves them unconditionally, and some talk about how they are learning to emulate her openness in their own relationships.

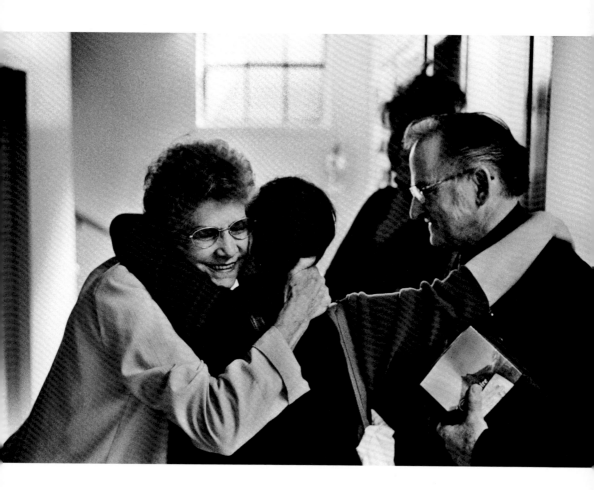

Margaret lives with a young couple and their two sons in a house in a new suburb
of Lethbridge and carries photographs of the children in her wallet. In the evening
before the boys go to sleep, she gives them each a goodnight kiss.

Margaret's bedroom is in the basement where, she likes to tell visitors, she has
her own bathroom. Routine is important: she wants everything in her room to
be just so. On weekends she often spends hours playing music and rearranging
her many photos of family, friends, and movie stars.

The quilt on Margaret's bed is a patchwork made from old jeans, a gift
from her support group on her thirty-seventh birthday. The denim squares
have names on them, the same names that Margaret prints on pink birthday
party invitations each September. "My friends," she says as she spreads the
quilt across her lap.

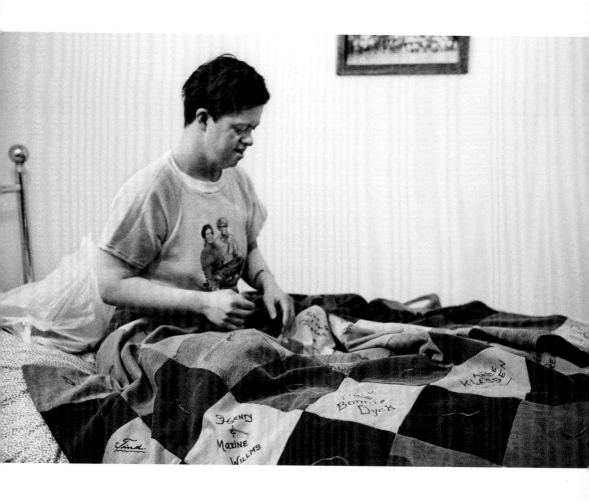

Margaret spends every other weekend with her parents, Jake and Kathe (pronounced "Katy") Enns, who still live in the house that Margaret grew up in. Margaret usually sets the table for meals, and her parents always ask her to say grace. "God is good," she says, "let us thank him for our food." When she's finished eating, Margaret hops up to clear the dishes, then goes to her room and listens to music. "She's getting so independent," her mother says. "So confident."

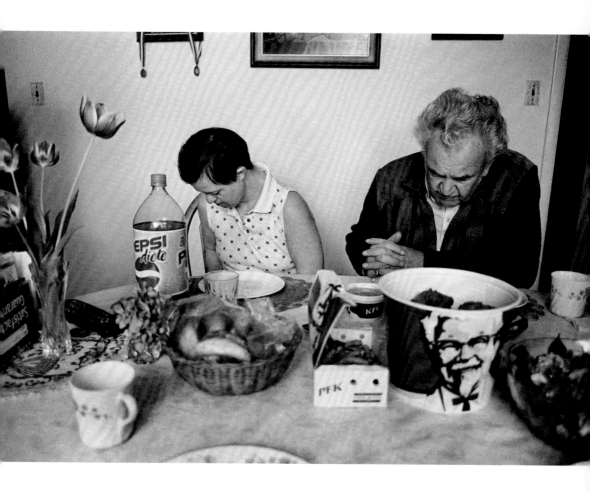

Jake and Kathe grew up in a Mennonite village in the Ukraine, and they were teenage sweethearts when World War II began. Jake was drafted into the German army, then taken prisoner by the Russians and sent to Siberia to work in a coal mine, where he took comfort from a small Bible that Kathe had given him. The same Bible travelled with him to a refugee camp in Germany, and then across the ocean to where Kathe waited for him in Canada.

A few weeks after Margaret was born, the doctor told her parents that their new daughter might never walk or talk. She had been born with an extra chromosome that would affect her growing up. The condition was called Down syndrome and no one had yet pinpointed what caused it, but doctors did know that the likelihood of having a baby with Down syndrome increased when a woman was older than thirty-five, as Kathe was.

It was hard to accept what the doctor said, and for a time Kathe kept her new baby at home and cried a lot. She and Jake were afraid that people would react to Margaret the same way Jesus's disciples reacted to the blind man of whom they asked: Who was sinning, this man or his parents, that he should be born like this? They wondered if they were being punished.

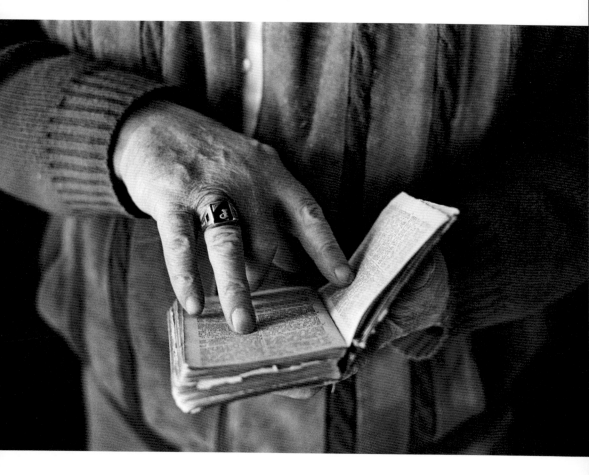

Some of the specialists they talked to said it would be best for everyone if Margaret was put in an institution, but Jake and Kathe chose to listen to their family doctor, who told them to take their daughter home and love her. Margaret was a vibrant baby and soon Jake and Kathe were taking her everywhere with them. There were challenges: sometimes neighbourhood kids were mean to Margaret, who wouldn't do anything to defend herself, and Jake and Kathe learned through the grapevine the hurtful things that some people were saying. Some of their neighbours seemed to think that Down syndrome was contagious.

The family became active in the local association for community living, a group of people with developmental disabilities and their families who were helping to erase the superstition of earlier decades when children like Margaret were hidden away. Living with Margaret changed not only their own unfounded prejudices, but those of family and friends as well.

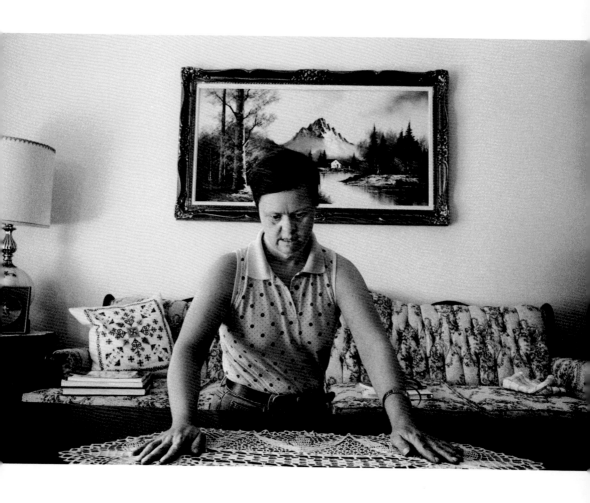

Margaret grew up walking and talking, though her speech could be hard to understand. She got involved with Special Olympics, joined a bowling team, and became a prize-winning swimmer. Her parents drove her to tournaments, helped her hang medals on her bedroom wall, and cheered when Margaret graduated, along with a hundred other kids from the local high school. "She's been a real blessing to us," her father says.

After high school graduation, Margaret continued to live at home with her parents, in the same room she'd been sleeping in since she was five. Ten years later she was still there, and her parents, now in their late sixties, were having some health problems. That was when Jake and Kathe got a call from Tom Cain, the leader of the local association for community living.

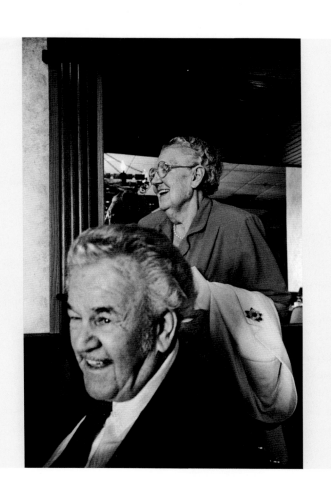

Tom and Margaret had been getting together for coffee, and lately Margaret had been saying that she wanted to be like other people her age and move out of her parents' home. Tom suggested that the best way to help Margaret move out might be to organize a support network.

Jake and Kathe felt uncomfortable asking other people for help, but they were worried about how Margaret would get by if something happened to them. So, on a summer evening fifteen years ago, they invited friends from their church to come over to talk about the idea. When Tom asked the group who would be willing to support Margaret, almost everyone in the room volunteered to be part of the network.

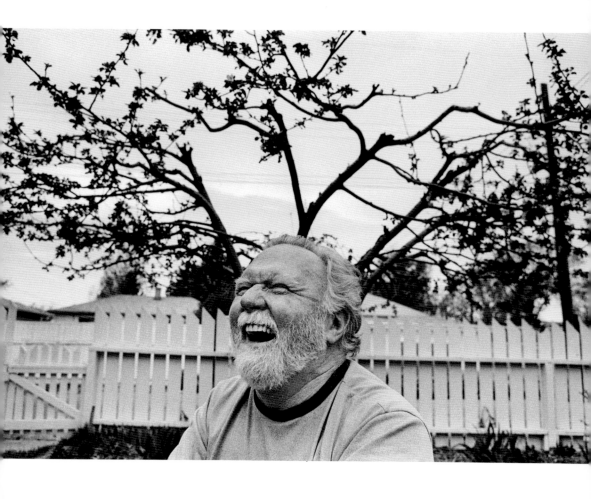

A few members of the network helped Jake and Kathe investigate the independent living options that were out there for Margaret. They toured group homes, talked to other parents, and learned about the government funding that would be available to cover Margaret's room and board.

Kathe was reluctant to let go. She worried about what Margaret would eat, how clean the place would be, and how Margaret would manage if anything went wrong. "All of us make changes in life," Tom reassured her. "Margaret will get over this and go on to the next step."

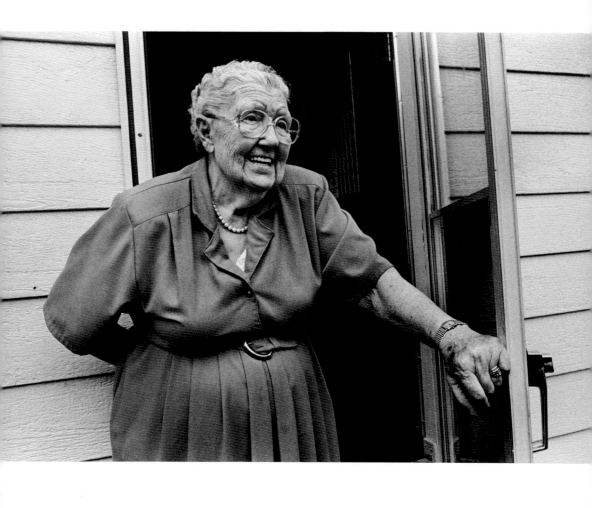

The support of the network made it easier, and before Margaret's thirtieth birthday, network members helped her move into a group home with two other young women who also had disabilities. Margaret lived there for a few years before deciding she was ready to try something different. She spent a year in the home of a young couple who received a stipend to act as her live-in companions, then two years with a woman who was going to university. Margaret liked the live-in companion arrangement and loved being part of a family. Her mom asked a young woman who had worked with Margaret before if she and her husband would be comfortable having Margaret live with them, and they agreed. Five years ago, members of the network helped move Margaret into the home, where she still lives happily with the young woman, her husband, and their two little boys.

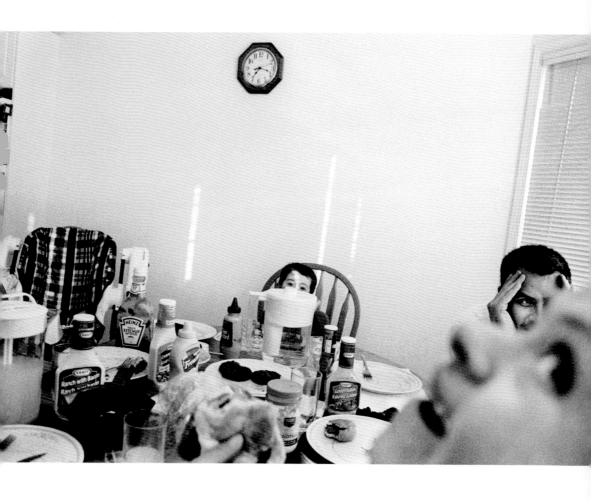

Back on the summer evening when Margaret's group began, one of the people in Jake and Kathe's living room was a woman named Anne Neufeld, who had a nephew with Down syndrome a thousand miles away. Unable to be part of her nephew's daily life, Anne welcomed the chance to be in Margaret's. The summer before Margaret moved out of her parents' home, Anne stayed with her while Jake and Kathe took their first vacation alone. When Anne discovered that Margaret had never made her own lunch, she stood behind her at the kitchen counter and took her through the steps of buttering bread, spreading jam, cutting the sandwich, and wrapping it in cellophane. Margaret has made her own lunch ever since.

Anne took on the job of facilitator for Margaret's group. She organized meetings and set agendas, and she helped Margaret plan her September birthday party, which has become an annual potluck extravaganza in the church basement, attended by as many as fifty people. "When we accept Margaret, we accept one another as well," says Anne.

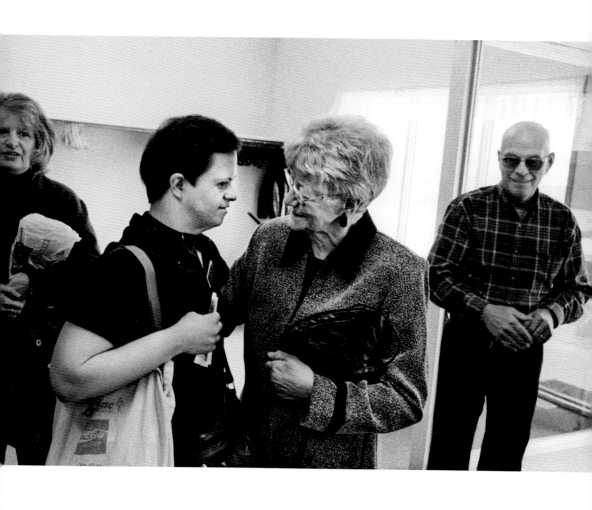

Before and after church services each Sunday, Margaret bustles around greeting people, giving them hugs, and showing them the latest entry on the well-worn card where her weekly bowling scores are recorded. Her friends say that Margaret makes them feel special. If one of them misses church, she wants to know why. If someone is sad, Margaret can feel it. "You okay?" she'll ask. And if the answer doesn't ring true, she'll ask again. "You sure?"

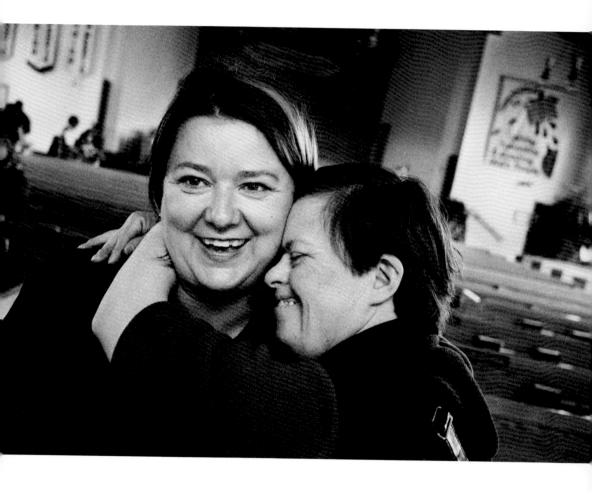

In recent years, Margaret has become more confident about approaching people. She has also become better at making herself understood. Margaret speaks rapidly and uses short phrases that can be hard to understand. Years ago, if someone didn't get what she was saying, she would repeat herself once or twice and then give up, but now she patiently repeats herself as many times as necessary.

"Movie. Let's go," she says when she phones up one of the women in her network. Margaret likes 'chick flicks,' so the men in her network usually beg off. But whether it's a love story on the big screen or just a game of cards at a friend's dining-room table after dinner, Margaret looks forward to outings all week. And if anyone mentions cheesecake, her eyes shine. "Please, please, please," she pleads, and she puts her hands together. The Cheesecake Café in downtown Lethbridge is her favourite restaurant.

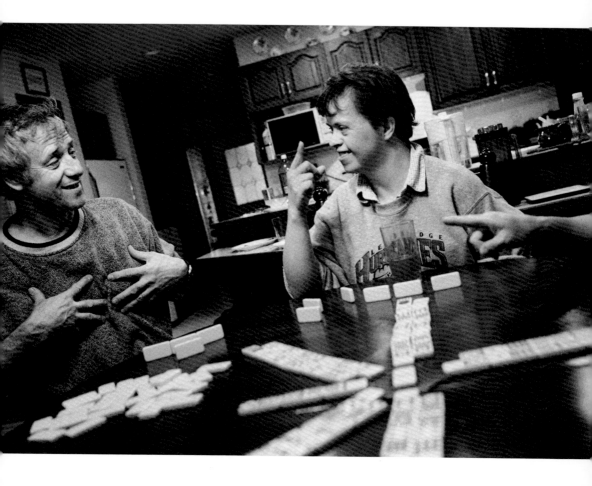

The Cheesecake Café is packed the night Margaret goes there with her friend Linda Giesbrecht after a game of miniature golf. Margaret's friendship with Linda began while Linda's husband was in the final years of a long illness. Linda was turning down most invitations to get out of the house, but that didn't stop Margaret from cajoling Linda into joining her for the occasional movie. The movie dates turned out to be a good break for Linda, and Margaret's Sunday hugs were a comfort. Since her husband passed away, the movie and cheesecake outings have continued.

"Margaret touches the hidden parts of my heart," Linda says. "I can see now that I've been receiving care from someone I thought of only as needing care."

When Anne was diagnosed with bone cancer and her prodigious energy began to wane, Linda volunteered to take over as the facilitator of Margaret's network.

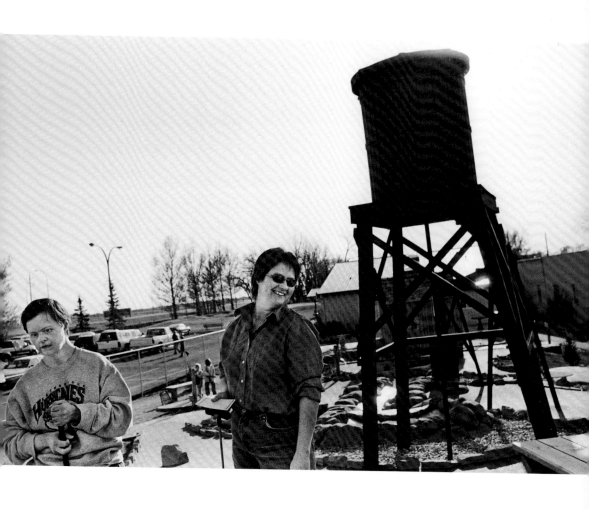

Over the years, the group has grown to several dozen. For many of those involved, what started as a Christian duty has turned into a deepening friendship. Margaret was always included in church activities, but people in the group feel more a part of her life now and more a part of one another's lives, too.

Anne remembers how she saw, at the first meeting of the network, that in pulling together to support Margaret, members of the group became better at supporting each other. For months now, Anne's illness has made it hard to enjoy a meal, but one afternoon a gift of homemade chicken soup from a woman in the group goes down easily. Anne has seen that when we support those who are most vulnerable, everyone benefits. "It is not just for people with disabilities," she says, "it is also for us."

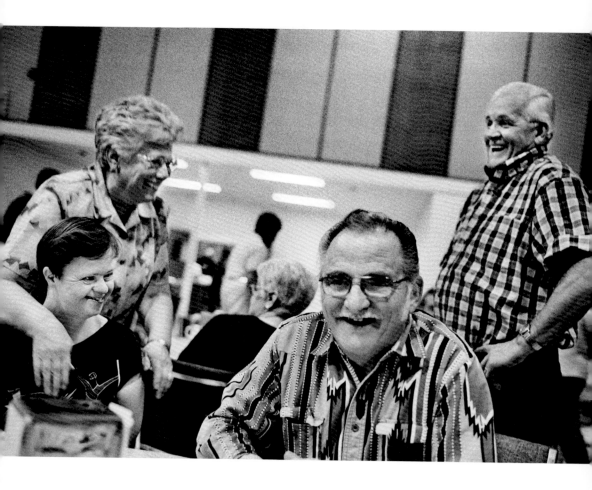

The next Sunday at church, Anne's name is on the Prayer Focus list in bold type. During the week she has been rushed to hospital. Her family gathered around her, and for two days her life hung in the balance. Now the worst appears to have passed and Anne's husband Vern assures everyone that Anne is going to be fine.

After church, Margaret and her parents visit Anne at the hospital, where she is surrounded by family and flowers. They have brought a small commemorative plaque that they had engraved with Anne's name and her years of service to Margaret's network. When Margaret presents it to her, Anne has to wipe the tears away. "You build a foundation," she says, "and it goes on from there."

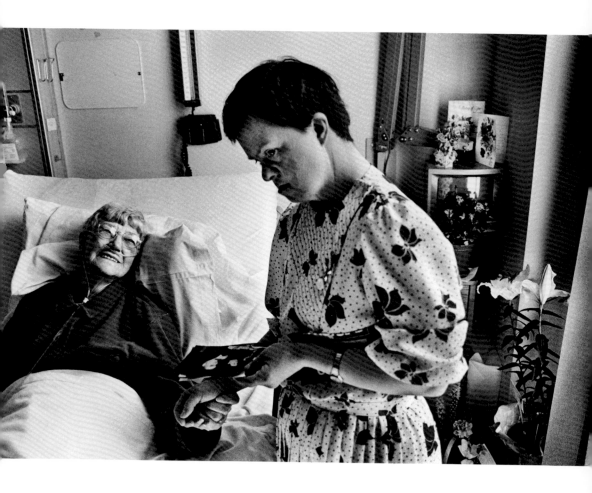

Anne suggests that a photograph be taken, and Vern finds a place for Margaret to sit on the edge of the bed. Anne reaches an arm around her shoulder, and everyone in the room who has a camera starts taking pictures.

Margaret holds Anne's hand for a moment and says goodbye.
Then she turns to Vern and gives him a big hug.

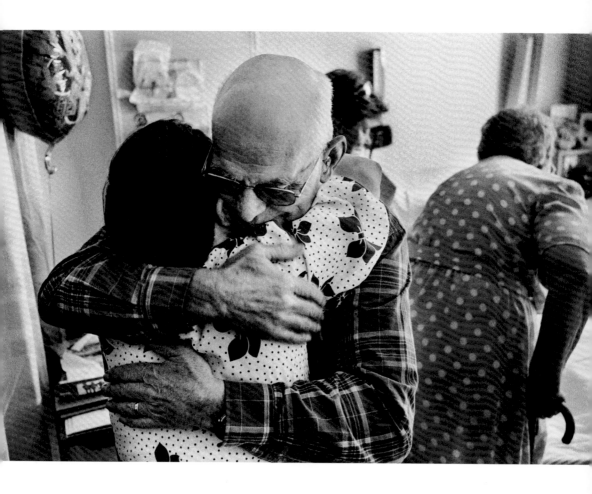

Rick

RICK OTTONI LIVES IN THE NOTRE-DAME-DE-GRÂCE neighbourhood in Montreal. Thirty-three years ago, when he was in first-year psychology at McGill University, he experienced a schizophrenic breakdown. The police found him wandering around at night, speaking and acting strangely. They assumed that he was on drugs and put him in jail. In the morning he was hospitalized, and two months later he came home heavily medicated.

His illness became a wall between him and the world. He lost his ability to understand what other people were saying and had a hard time making sense when he talked. He got a job in a factory where he passed the day convinced he was incapable of doing the work and fighting the side effects of the strong anti-psychotic drug, which dulled his mind, made his body stiff and jittery, and caused him to drool at times.

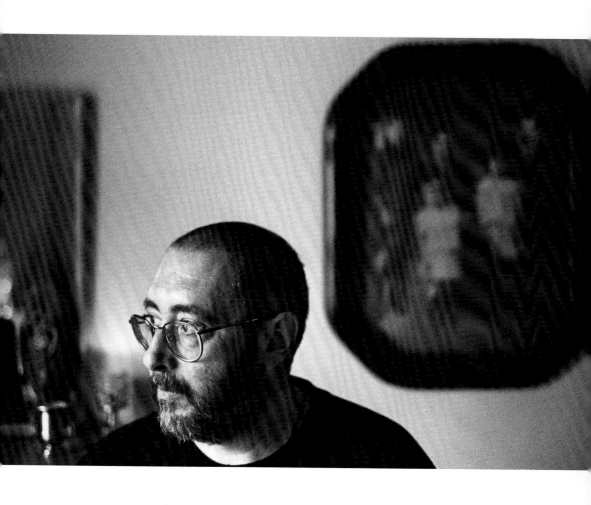

"I lived at home until I was thirty-four because I really couldn't live on my own," Rick says. His parents were supportive, but in the 1970s there were few resources to help a family understand the illness that left their son exhausted, confused, and often impossible to talk to.

Schizophrenia is linked to imbalances in the chemistry of the brain that often develop when people are in their teens or early twenties. Anti-psychotic drugs help bring serotonin and dopamine levels back into balance, and for Rick they eventually worked well enough that he was able to return to university. He was close to finishing an engineering degree when his doctor decided he was doing so well he didn't need medication any more. Rick ended up back in the hospital. Fifteen years later, after another crisis with his medication, Rick again lost the ground he had gained. He was filled with guilt and shame about his illness; he became paralyzed by depression and soon he was staying in bed all day and night.

"Loneliness is a cancer of the soul," Rick says. "I was dying of loneliness."

He was back in the hospital when he learned about L'Abri en Ville, an organization that sets up homes for people with mental illness and organizes volunteers to help support them. When Rick was released he moved into one of their apartments. That was ten years ago.

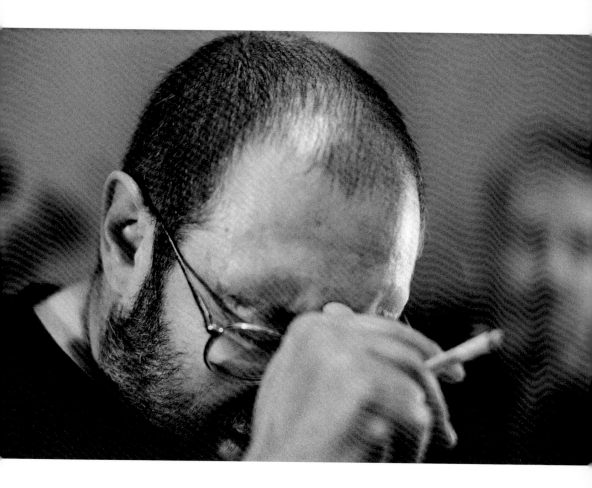

Rick shares the apartment with two roommates who also live with schizophrenia. George grew up in Montreal, and has a master's degree in architecture from Yale. He was living in New York when he started hearing voices, and although medication helps, he has been hearing voices ever since. He once had an apartment over a bus stop, where he constantly heard the sound of unseen people talking about him. George still works at his drafting table when he can, but this year he's been sleeping a lot. Often he stays in his room until noon. When he emerges, the others are always glad to see him.

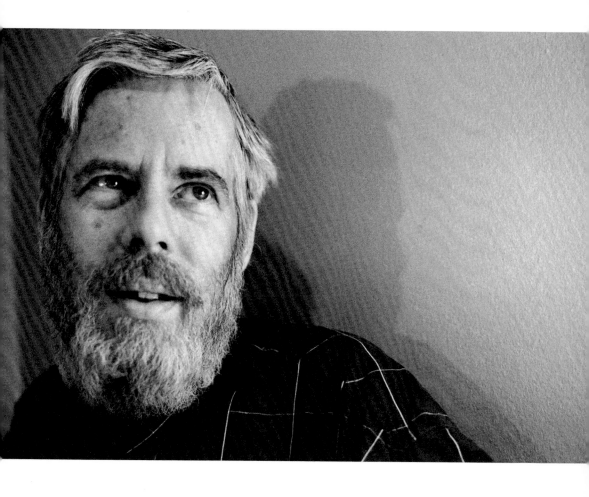

David is the youngest of the three. When he moved in two years ago, he brought a playfulness into the apartment that all the men enjoy. He was taking a break from his university studies when he experienced his first schizophrenic episodes, and even now with medication he continues to suffer periodic delusional thinking that makes him anxious and can leave him weak and shaking.

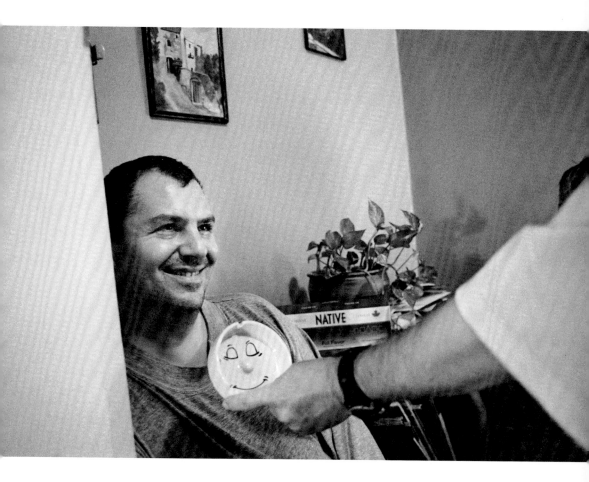

The kitchen table is where the men gather to chat and help one another sort out what's real and what's not. George jokes that they have compatible illnesses. Schizophrenia is commonly misunderstood to be a disease of multiple personalities; in fact it is a disease that affects perception, emotions and thought processes. Anti-psychotic drugs help to control some but not all of the symptoms of schizophrenia. Stress can aggravate the condition, so although Rick would like to get a job, he fears the pressure would lead to a relapse.

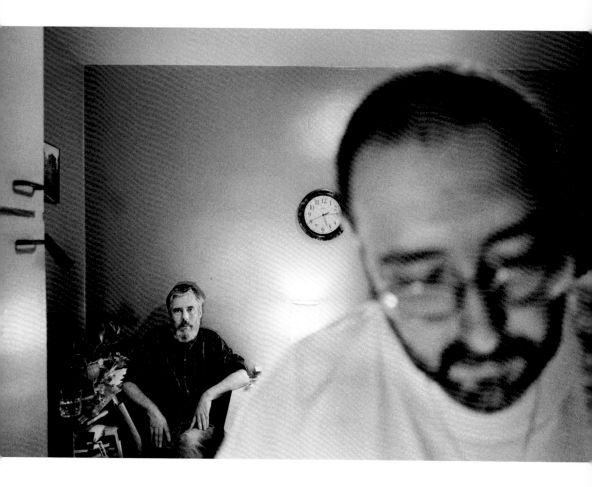

Marianne Metrakos, a co-ordinator with l'Abri en Ville, visits the apartment once a week and has become a good friend to the three men. She checks their medications, listens to their concerns, and talks about what they want to achieve. These days George tries to get out for walks more often, David is getting used to riding the bus again and Rick takes an art class downtown.

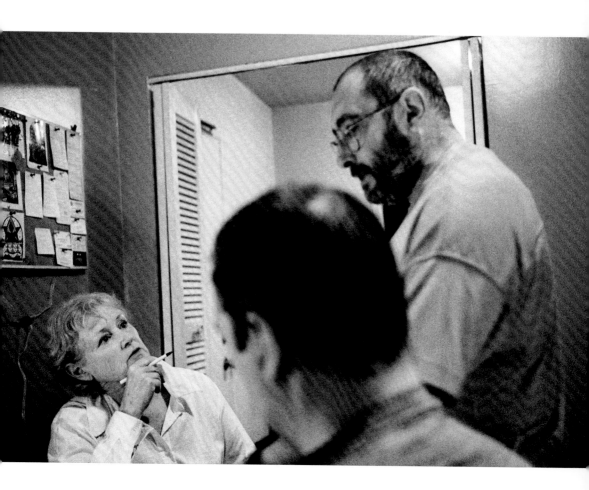

Over the years, the volunteers assigned to the apartment have become friends of the 'family.' Some stop by just to visit, while others come to help Rick and his roommates with groceries, laundry, and housework.

"Without them, it falls apart," Rick says. "When you have certain kinds of mental illness, you have very low motivation and you don't keep on top of things." He knows now that domestic order is essential. "You have to keep the basics going before you can do anything else."

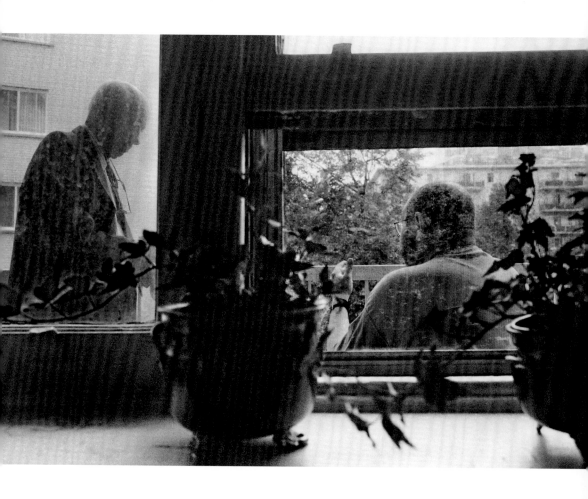

When Nancy, a retired social work administrator, comes to help with the cleaning, she usually finds Rick or David washing dishes or vacuuming in anticipation of her arrival. "We know when they're here, it's time to do it," Rick says. "They encourage us. There's no slave driving going on here, but it helps an awful lot to keep things on track." If George has just gotten out of bed, Nancy sits with him at the kitchen table while he has a coffee. One afternoon she tells him about her weekend in the country, and he invites her to an exhibition of his sister's paintings. After they talk for a while, George says he should do a load of laundry, and they set to work.

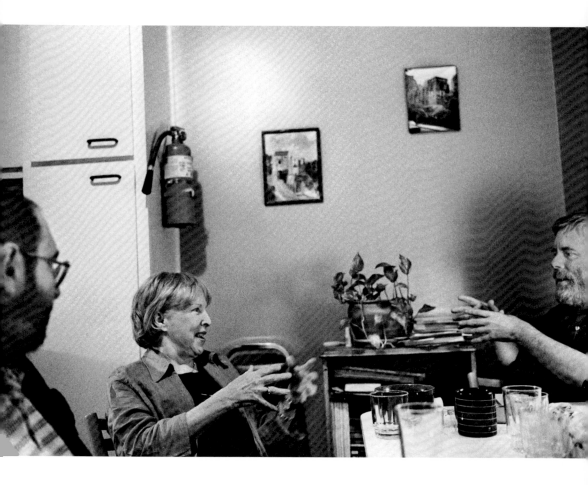

Claude is a retired CEO. He comes every Tuesday for the grocery shopping. "The volunteers really care for us," Rick says, "which in itself can be quite therapeutic, because often people with a mental illness get the response from society that they're not accepted, they're not really worthwhile members of society."

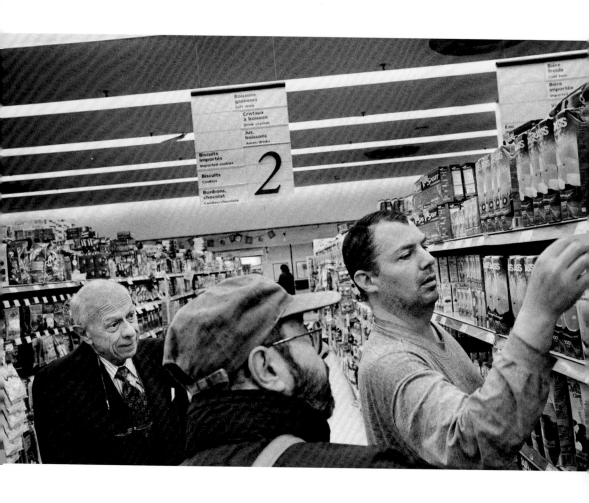

Boissons
gazeuses
Soft drink

Cristaux
à boisson
Drink crystals

Jus,
boissons
Juices/drinks

2

Biscuits
importés
Imported cookies

Biscuits
Cookies

Bonbons,
chocolat
Candies/chocolate

Bière
froide
Cold beer

Bière
importée
Imported beer

Eau

On a Sunday afternoon, the smell of roast pork fills the apartment. At one time Rick would have had difficulty even setting the table, but now he cooks for his roommates most nights. Well before the roast is pulled from the oven, George and David are already at the table, joking around. "I have built-in friends," Rick says, "just like the brothers I never had."

One of Rick's biggest fears used to be that when his parents were no longer around he would end up on the street. He doesn't worry about that any more. He's still close to his parents, but their relationship has changed. He has his own home. He doesn't depend on them as he once did; instead, he's able to help them, giving them support as they get older.

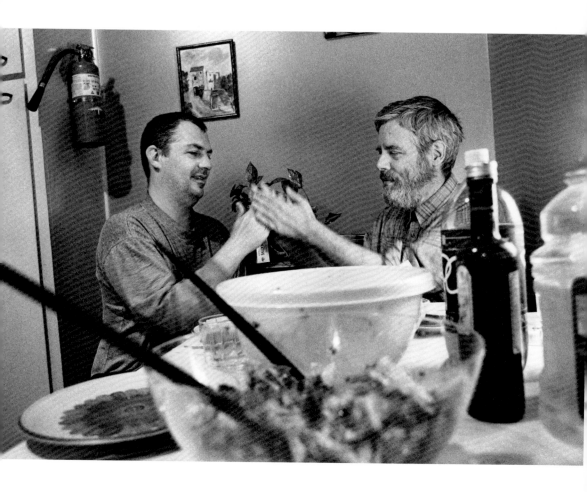

On days when George doesn't make it out of bed before mid-afternoon, Rick and David sometimes help to rouse him with friendly persuasion and jokes. "If one of us has a relapse," Rick says, "our world is not going to fall apart. There'll be somebody there to catch us, and we'll get the help that we need and we'll come back to our home."

After what they've been through, Rick and his roommates are more inclined to see people's strengths than their flaws. "When you're deprived of something as basic as the proper functioning of your mind," Rick says, "that's a horrible kind of poverty, so you get to appreciate little things."

Gerry is a regular visitor who shares Rick's interest in theology. One afternoon they talk about an exchange between a Jesuit priest and his student in which the student asks, "What is love?" and the priest replies, "Love is the absence of fear." "What do we fear?" the student asks, and the priest answers, "We fear love."

Gerry says that we fear love because it is so total, because we are vulnerable when we love. "I don't think life is worth living," Rick says, "unless there's an exchange of love."

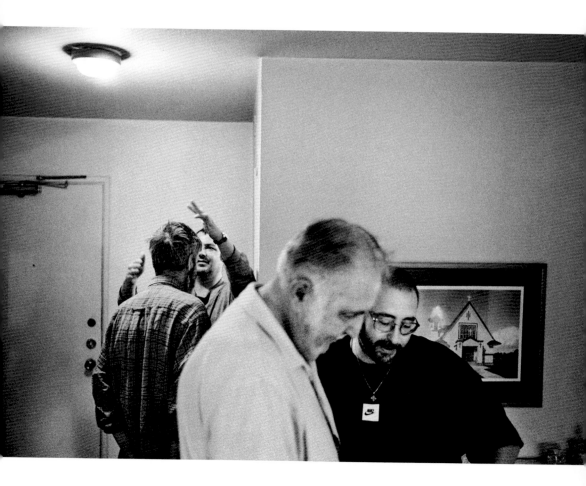

When he first moved into the apartment, Rick couldn't go into a grocery store without panicking and having to run outside. Now he shops with ease. One afternoon he sips espresso at a neighbourhood sidewalk café and talks about his roommates and their circle of friends. "I'm reconnected to life," he says. "We take care of each other. That's not always available to everyone."

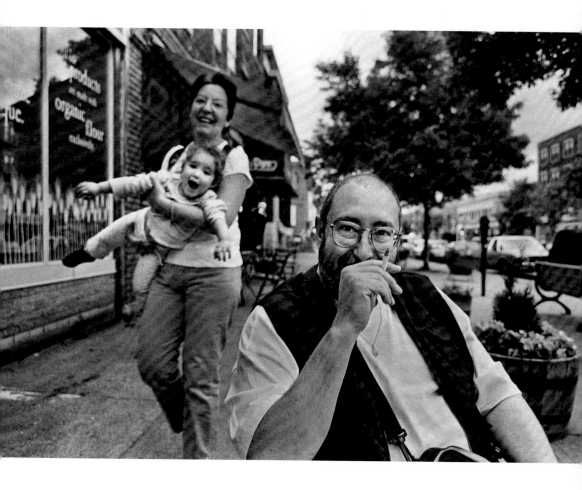

Erin

ERIN TESAN IS TWENTY-SEVEN YEARS OLD and lives in Vancouver with her parents, three brothers, and two cats. In the late afternoon she curls up on the couch in the family room and watches *Oprah* with her mom.

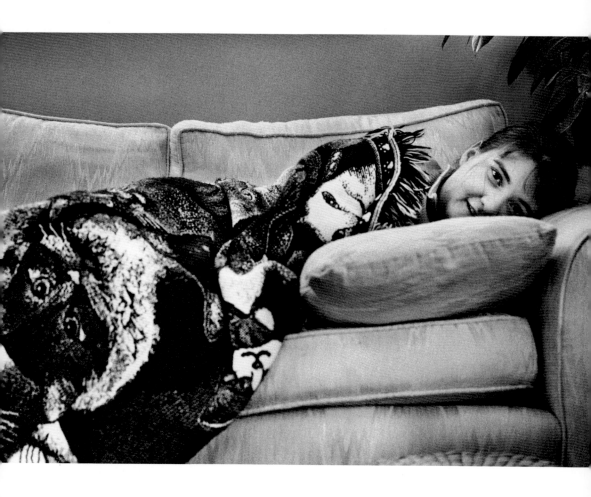

Erin's father is a teacher, and so is her older brother. Her younger brothers are teenagers and keep the family busy with soccer practice and hockey tournaments. Erin is a dedicated hockey fan and goes with her mom and dad to many of the games, where she drinks hot chocolate in the stands and cheers her brother on.

"We go now?" Erin asks soon after they take their seats in the local arena. Her voice is light and high and she speaks quickly. When her mom doesn't reply right away, Erin repeats the question and her smile turns worried.

"No, we're going to stay here for a while," her mom says. "Is that okay?"

Erin settles back in her seat and takes a sip of her hot chocolate. "Okay," she says.

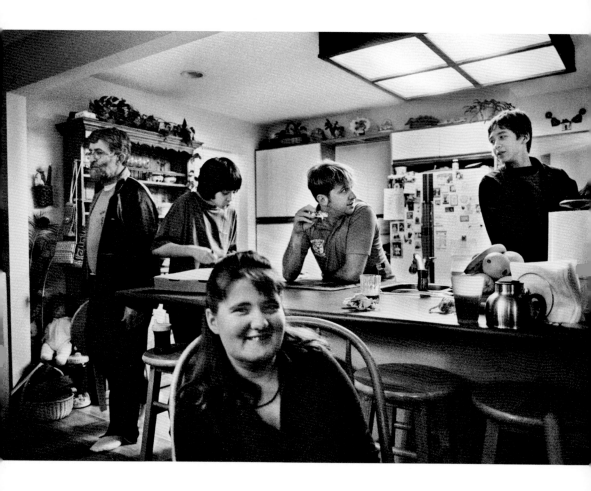

When Erin was three years old, her parents took her to the doctor because she wasn't talking much and her comprehension seemed to be lacking. After a week of tests, a psychologist at the hospital told her parents the doctors didn't know why, but Erin had a mental disability. He said there was nothing they could do.

Over the years, doctors ran other tests in a search for a specific diagnosis, but never found one. Erin's mother Pat began reading books about disability, meeting other parents of disabled kids, and going to workshops put on by people who were part of a movement for disability rights, which was beginning to gain strength across North America. For a while Erin went to a special-needs preschool, where she was treated like a princess and always came home with clean clothes. Pat thought that was great, but then she realized that Erin wasn't talking and neither were any of the other children at the preschool. She found a regular preschool with a reputation for being innovative, and soon Erin was talking more and coming home as dirty as the other kids.

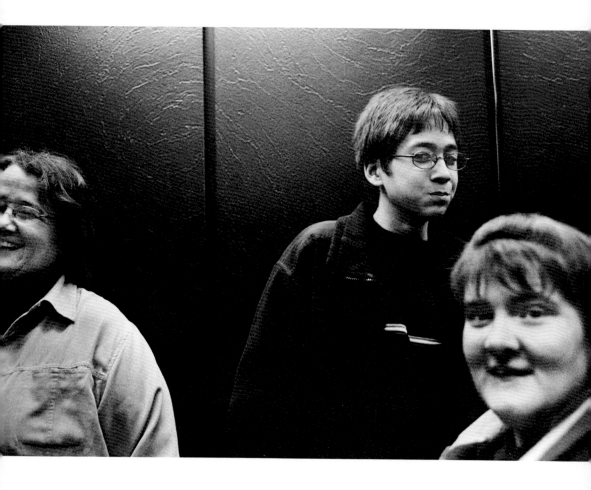

Erin started elementary school a half-hour's drive from home, as part of a special needs class in which the kids spent very little time in regular classes with their peers. Her parents wanted Erin to have as much time as possible in a standard classroom, so they organized the first of many meetings with school officials. Over the next four years they were told that integrated education was impossible, that it would be bad for Erin, the other students and the teachers, and that if the school did it for Erin, they would have to do it for "everyone."

Still, it was a time of change. Segregated schools were being closed, and across the country parents like Pat and Ric pushed to have their kids with disabilities included in the public education system. In Grade Five, Erin entered a regular class at her neighbourhood school. That was when Pat set up Erin's first circle of friends, as a way for Erin and her new classmates to get to know one another. Soon Erin had kids to eat lunch with and birthday parties to go to. She never learned to read or write, but by hanging out with other kids and doing what they did, Erin's verbal and social skills improved, and she played, had fun, learned how to make friends, and became part of the community. Her high-school graduation was a gala affair captured in photographs in a silver album that sits in the living room.

After high school ended, Erin spent her weekdays with one of her support workers—two young women who each worked part-time, splitting the week between them. One of them arrived at eight in the morning to help Erin get dressed and do her hair. Sometimes they drove downtown to a part-time job in an office, where they spent the morning folding and stapling brochures or doing photocopying: Erin pushed the button once the documents were set in place. On Tuesdays, Erin volunteered at Safeway doing shopping for housebound seniors. She took a wellness course at the local college, swam laps at the pool, and for a while worked at a nearby coffee shop.

Erin's parents managed the funding Erin received from the government for her day program, so they hired the support workers. The intimacy of being Erin's daily companions made these young women part of the family, and most stayed in touch with Erin and her parents after leaving the job.

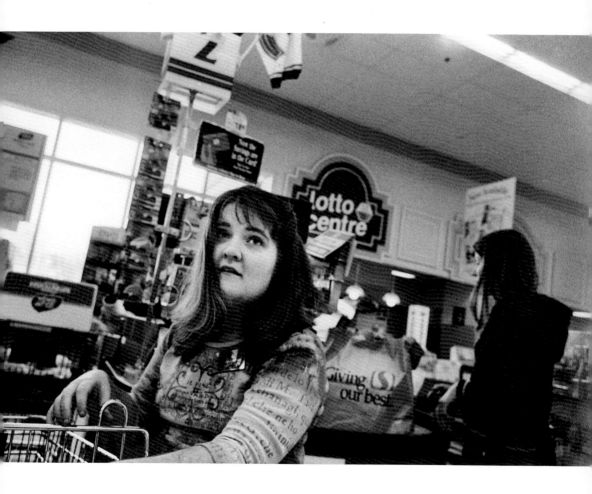

When her school days were over, Erin didn't see her friends as often. Most of the girls in her circle moved away to jobs or university. They got married and had kids. Her two closest schoolmates moved away in the same year, and Erin had a hard time staying in touch. Without school to bring Erin and her friends together, her social life waned, and Pat began to worry that Erin would become isolated and end up spending every night on the couch watching TV. So when Erin was twenty-one, Pat and Ric joined PLAN, a non-profit organization that sets up networks for people with disabilities, and hired a facilitator to start up another circle.

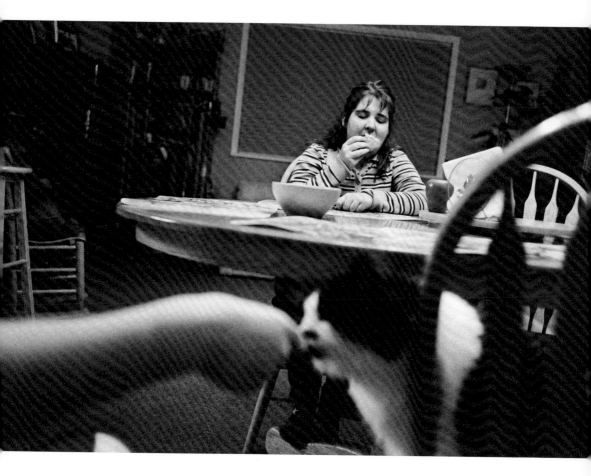

Some of the women who joined the new circle are old schoolmates of Erin's, several are former support workers, and one is a family friend. Some bring their young children along to the circle gatherings, which are usually lively.

On a summer afternoon, Erin's circle gets together at one of the women's homes for a barbecue. Erin, who has come with one of her friends, is among the first to arrive. The hostess has provided beef and veggie burgers, and everyone else brings an appetizer or dessert, so the kitchen is soon full of food. A blond-haired boy, the son of the hostess, has a new haircut, and as the women exclaim over how handsome he looks, Erin tells them she has a new haircut too, and they compliment her as well. The sound of kids at play punctuates the conversation as the women slice tomatoes and butter buns and talk about the shape of their lives: summer holiday plans, the new hair colour one of them wants to try out, the demands of work and husbands and kids.

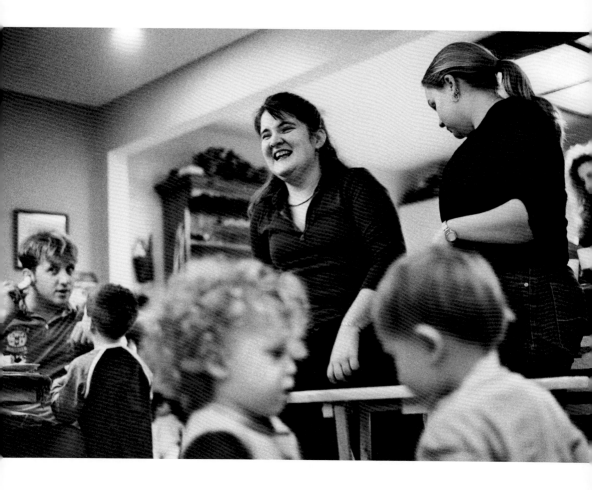

One mom tries to teach her two-year-old not to double-dip her tortilla chips in the guacamole. They all check up on Erin, making sure she has enough juice, asking if she wants barbecue sauce, assuring her, when she says she is hungry, that the burgers will be ready soon. After supper, the kids disappear upstairs to jump on the master bed while the women linger over coffee and cake and girlfriend talk.

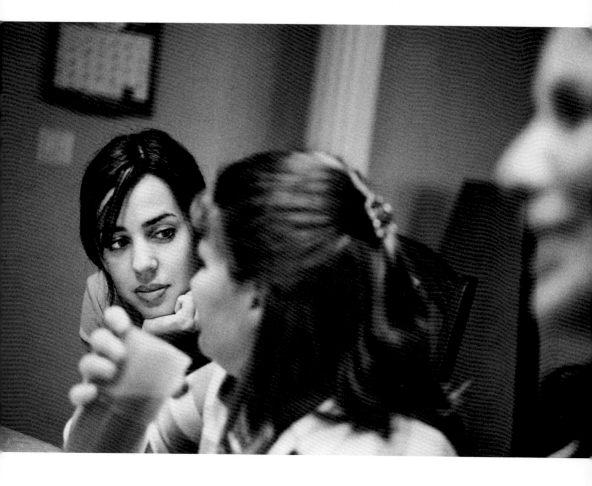

Since Erin brought them into one another's lives, her girlfriends have become a close-knit group. Most of them grew up around disability. A few years ago, they volunteered to work together to facilitate the circle, and now one of them spearheads a get-together every month or so. Erin's parents still worry about what will happen when they are not around any more, but her friends say they will always be there for Erin and talk about how her happiness rubs off on them.

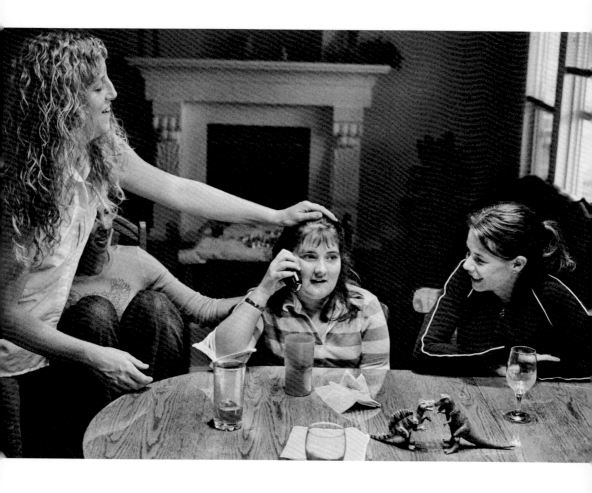

One rainy morning in the spring, Erin heads off to a stable in the country, where she rides a well-behaved horse named Jake. Her girlfriend Carla Henderson, who is part of the circle, has riding lessons at the same time. The two women met in high school.

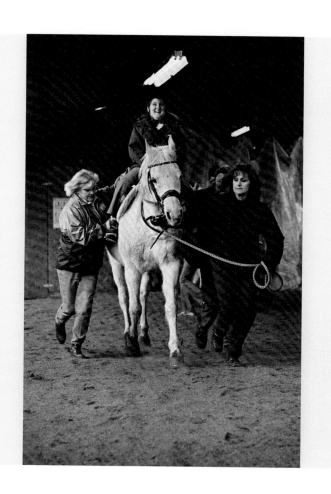

After riding, they head back to Erin's place for hot soup. Carla survived a bad car accident just before her sixteenth birthday and spent months in a coma and two years in the hospital. She uses a wheelchair. Lately she has been looking for a job, but so far she hasn't had any luck. As they eat, Carla expresses her frustration at looking for work before switching to talk about the hot date she has for an upcoming St. Patrick's Day dance.

"Erin, will you be out there shaking your booty?" she asks.
"I have a good feeling you will be."

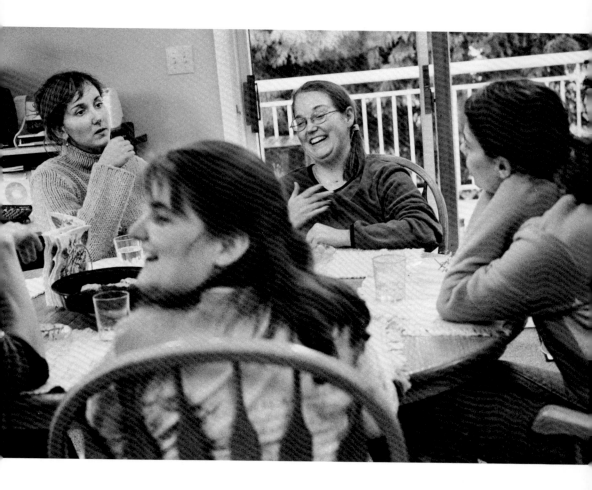

Erin's girlfriends make sure she goes places and sees people — the things she loves but can't do without a companion. She is quick to accept invitations to go for coffee, and a few years ago she went on an Alaskan cruise with one of her friends and a support worker.

Erin loved to go shopping with her mom when she was a girl, and she is always up for a trip to the mall with one of her girlfriends. One evening when Laura Hussey, another friend from the group, picks Erin up for a shopping spree, her family gathers around the top of the stairway and chats with Laura for a few minutes. Erin's dad jokes about whether he should be giving his credit card to two young women who are headed to the mall, and everyone shares a laugh.

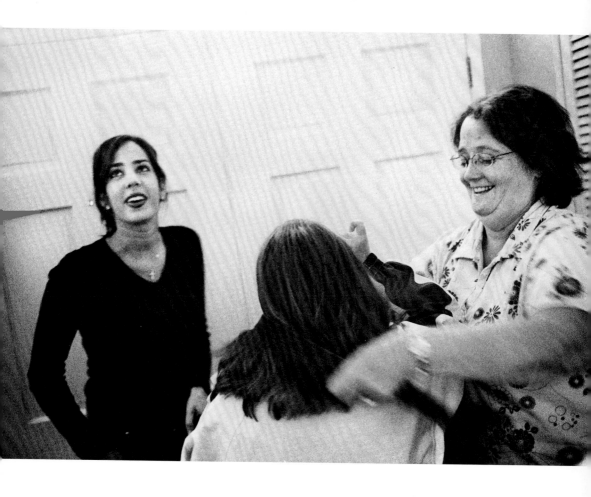

"I want to go shopping," Erin says once she and Laura are in the car.

"Good. What shops do you want to go to?" Laura asks.

"Dairy Queen," Erin says.

Laura suggests that they buy some clothes first. Loud rock music plays in the boutique, where Laura holds up a green cardigan and an orange one. "Which colour do you like?" she asks. Erin reaches for the green one. They buy the cardigan, two pairs of pants, and a shirt. The more bags she carries, the slower Erin walks.

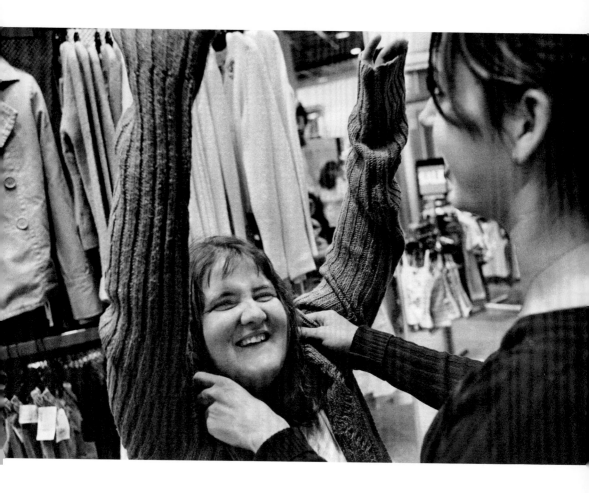

"Movie?" Erin asks as they get ready to leave the mall.

"Not tonight," Laura says.

"Maybe tomorrow?"

"Maybe tomorrow."

Acknowledgements

OUR HEARTFELT THANKS TO Jeff Moorcroft, Betty Terbasket, Margaret Enns, Rick Ottoni, and Erin Tesan for accepting us with our cameras and questions and trusting us to share their lives with others. Thanks also to their family and friends: in Nelson, Megan Moorcroft, Deb Kozak and the members of Jeff's network; in the Okanagan, three generations of the Terbasket family; in Lethbridge, Jake and Kathe Enns, Tom Cain, the Carroll family, and the members of the Coaldale Mennonite Church who make up Margaret's network; in Montreal, Rick's roommates George and David and their L'Abri en Ville network; and in Vancouver, the Tesan family and Erin's girlfriends.

The roots of this book reach back more than thirty years to the birth of Sandra's younger brother David, who taught her that you don't have to be verbal to communicate. The love and generosity of Sandra's parents, Clair and Rochelle Shields, sustained us through this project as it has through previous ones. In Regina we counted ourselves lucky that Heather Malek and Robin Schlat were in the right place at the right time. For sharing their homes with us, we are grateful to Bodina Ersfeld in Vancouver; Kelly, Madeline, and Sophia Terbasket in Blind Creek; Julie, Bruce, and Abigail Heninger in Calgary; Tami, Kevin, Rebecca, Emily, and Andrew Livingstone in Lethbridge; Jonathan Browne and Julie Witmer in Ottawa; and Beryl and Roger Lemoyne in Montreal. While on the road, we were reminded that support is not just a

human affair when our faithful travelling companion, a border collie cross, took sick and died, leaving a hole in our circle. We are grateful for the ongoing encouragement from our friends in the game: Elaine Briere, Don Denton, David Evans, Brian Howell, Todd Korol, Bob Semeniuk, Tim Van Horne, Kristen Wagner, and George Weber. Finally, thanks to Finbarr Wilson for conversation, Bill Damer, and Noreen Branagh for doing the real work, and Michael Simpson for keeping us honest.

The enthusiasm of Vickie Cammack and Al Etmanski was crucial to bringing *The Company of Others* into the world. Thanks also to Nancy Rother and the folks at PLAN. We were fortunate in having the combined editorial expertise of Mary Schendlinger and Stephen Osborne, and the publishing know-how of Arsenal Pulp Press.

Resources

There is a growing body of resources available on the subject of circles and social networks. The following is offered as a starting point for those interested in learning more.

BOOKS

PLAN Institute for Caring Citizenship has numerous resources and publications about social networks and circle-building, including Al Etmanski's acclaimed guide, *A Good Life for You and Your Relative with a Disability* and the CD-ROM, *Peace of Mind*. *3665 Kingsway, Suite 260, Vancouver, BC, Canada, V5R 5W2; tel: 604-439-9566; www.planinstitute.ca*

Inclusion Press has books about social circles. Two titles of note are Judith Snow's *What's Really Worth Doing And How to Do It*, and Jack Pearpoint's *From Behind the Piano: Building Judith Snow's Unique Circle of Friends. 24 Thome Cres., Toronto, ON, Canada, M6H 2S5; tel: 416-658-5363; www.inclusion.com;* in the UK: *www.inclusiononline.co.uk*

Asset-Based Community Development Institute at Northwestern University has books on successful community-building initiatives in hundreds of neighbourhoods. *ABCD Institute, 2120 Campus Drive, Evanston, IL, USA, 60208-4100; tel: 847-491-8711; www.northwestern. edu/ipr/abcd.html*

The Institute on Community Integration at the University of Minnesota operates the web site *www.qualitymall.org*, which offers books about practices that help people with developmental disabilities participate in their community. *102 Pattee Hall, 150 Pillsbury Dr. SE, Minneapolis, MN, USA, 55455; tel: 612-624-6300; www.ici.umn.edu*

The Institute on Disability at the University of New Hampshire maintains a list of publications related to the lives of persons with disabilities and their families. *250 Commercial St., Suite 4107, Manchester, NH, USA, 03101; tel: 603-628-7681; www.iod.unh.edu*

FILMS

The Ties that Bind is a film and interactive website produced by the National Film Board of Canada as a resource for families who are worried about the future well-being of their relatives with a disability. *www.nfb.ca/tiesthatbind*

ORGANIZATIONS

Planned Lifetime Advocacy Networks (PLAN)

A family-directed organization based on the vision of creating a good life for all people with disabilities and their families; PLAN has supported ans inspired organizations in Canada, the United States, Scotland, Holland, and Australia. *3665 Kingsway, Suite 260, Vancouver, BC, Canad, V5R 5W2, tel. 604-439-9566, www.plan.ca*

Philia: A Dialogue on Caring Citizenship

A global conversation, arising from the disability community, about a notion of citizenship based on contribution, participation, relationship, and a commitment to the common good. *www.philia.ca*

L'Abri en Ville

An organization committed to providing secure and comfortable homes within a caring community for persons suffering from mental illness. *2100 Marlowe Ave., Room 342, Montreal, QC, Canada, H4A 3L5; tel: 514-932-2199;www.labrienville.org*

Circles Network

An organization working to build circles of support in England, Wales, Scotland, and Northern Ireland for people with learning difficulties and others who are at risk of social isolation. *Potford's Dam Farm, Coventry Road, Cawston, Rugby, Warwickshire, England, CV23 9JP; tel: 01788-816-671; www.circlesnetwork.org.uk*

Inclusive Solutions

An organization that provides practical strategies for developing inclusion in schools, colleges, and communities in the UK. *49 Northcliffe Avenue, Nottingham, England, NG3 6DA; tel: 0115-955-6045; www.inclusive-solutions.com*

L'Arche International

A federation of faith-based communities where people with developmental disabilites and others share mutually transforming relationships. *www.larche.org*; Canada: *www.larchecanada.org*; US: *www.larcheusa.org*; UK: *www.larche.org.uk*

The husband-and-wife team of SANDRA SHIELDS and DAVID CAMPION have collaborated on many projects, including the book *Where Fire Speaks: A Visit with the Himba* (Arsenal Pulp Press), winner of a BC Book Prize (the Hubert Evans Non-Fiction Prize) in 2003, as well as photo-based essays in publications including *The Globe & Mail, Canadian Geographic,* and *Geist.* Their story about the relationship Sandra shares with her severely disabled younger brother received a National Media Award from the Canadian Association for Community Living. They live in Deroche, BC.

JOHN RALSTON SAUL is the author of numerous books, including *Voltaire's Bastards: The Dictatorship of Reason in the West, Reflections of a Siamese Twin: Canada at the End of the Twentieth Century,* and *The Unconscious Civilization,* which won the Governor General's Award in 1996.